HAUNTED
AURORA

HAUNTED AURORA

DIANE A. LADLEY

Haunted America

Published by Haunted America
A Division of The History Press
Charleston, SC 29403
www.historypress.net

Cover image: Built in 1931, the former St. Charles Hospital is currently a nursing home and sanatorium; it is considered by many to be one of the top five most haunted places in the city. *Courtesy Aurora Historical Society.*

First published 2010

Manufactured in the United States

ISBN 978.1.59629.805.7

Ladley, Diane A.
Haunted Aurora / Diane A. Ladley.
p. cm.
Includes bibliographical references.
ISBN 978-1-59629-805-7
1. Haunted places--Illinois--Aurora. I. Title.
BF1472.U6L335 2010
133.109773'2--dc22
2010034443

Notice: The information in this book is true and complete to the best of our knowledge. It is offered without guarantee on the part of the author or The History Press. The author and The History Press disclaim all liability in connection with the use of this book.

This book is dedicated to the residents of Aurora, Illinois, past, present and future…to my beloved Dante and Banshee…and to the cherished memory of my parents, Walter and Norma Ladley.

CONTENTS

CONTENTS

ACKNOWLEDGEMENTS

The problem with thanking the Aurora residents past and present who told me of their true encounters with the paranormal is obvious: they don't want anybody to think they're nuts, exaggerators or shameless fibbers. To all of these sane, down-to-earth, honest people who shared their stories, I offer my heartfelt, yet discreet, gratitude. You know who you are, and you know that what you experienced was real.

Still others furnished unstinting assistance in the more mundane, yet equally valuable, historic research. My deep thanks and highest praise go to John Jaros and his research staff at the Aurora Historical Society. I also tip my hat to Matt Hanley of the *Beacon News*; Charles, the reference librarian at the Aurora Public Library; and my friend Bryan J. Ogg, research associate at Naper Settlement. My heartfelt gratitude goes to Scott Ascher and the outstanding staff at America's Historic Roundhouse, especially Chela, Alfonso and Leroy—I *love* you guys. Thanks also go to Les Buboltz; the entire Dabney family; Aimee Kennedy and Maddie; the staff and tech crew at the Paramount; and the staff at Spring Lake Cemetery. Special thanks go to Troy Taylor, Len Adams, Bruce Cline, Dan Jungles and Jason Sullivan for sharing their knowledge and experiences of the paranormal with me. If there's anybody I've forgotten (and I *know* I have), please forgive me.

There are a few people whose special kindness, enthusiastic support and friendship have made this book and my sanity possible. To them, words cannot express the depth of my gratitude, except to say, "Thank you, thank you, thank you, thank you!" These extraordinary people include my editors

of infinite patience, Ben Gibson and Jonathan Simcosky, at The History Press; the excellently ominous and fellow haunted historian and storyteller Curt Morley (aka Morgue the Mechanic); and the most wonderful, funniest and best neighbors in history, Lisa and Mike Condinho—to you I especially extend my most profound thanks for *everything*! In the City of Lights, you two shine brightest of all.

AURORA, THE CITY OF LIGHTS...AND DARK

"The brighter the light, the darker the shadow it casts." Nowhere is this ancient proverb more true than in Aurora, Illinois, with its official title as the City of Lights. The name "Aurora" itself contains hints of the good and evil dichotomy that seems to coexist in this city on the Fox River, currently the second most populous city in Illinois after Chicago. Legend has it that it was the sight of the shimmering, ever-changing radiance of the Aurora Borealis (the Northern Lights) in the sky above them that inspired founding brothers Joseph and Samuel McCarty to unite the original 1834 twin settlements on the western and eastern sides of the river under the single name Aurora in 1857. Of course, they knew that Aurora was the name of the beautiful, kindly goddess of the dawn in Roman mythology, so it was a poetically lovely name for their beloved town. This legend, while romantic, is untrue. In 1836, Samuel McCarty built a road running from Naperville to the McCarty's Mills settlement on the east side of the Fox River. He convinced the mail coach to drive out his way, which meant that the settlers had to petition for a U.S. Post Office and decide on a name for it. Their first choice of name was "Waubonsie," after the great Potawatomie war chief.

Waubonsie had ruled up to five hundred Potawatomi in a semipermanent summer base camp called Maramech, situated from year to year at various places along the Fox River from Plano to Batavia. He had deeply impressed the early pioneers, who made reference to his towering six-foot-four stature, strength, leadership and friendliness to the white man. Unfortunately, it

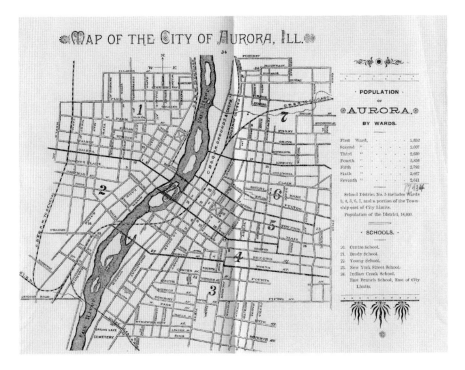

A map of Aurora, 1887. *Courtesy Aurora Historical Society.*

was in this same year, 1836, that the U.S. government moved Waubonsie and his people to a reservation outside of Council Bluffs, Iowa. The pioneers could think of no better way to honor their great friend than by naming their post office after him (though I imagine that Waubonsie would have felt that a greater honor would have been to let his people stay on their ancestral hunting grounds). But it turned out that there was already a Waubonsie Post Office in Illinois. So, in 1837, after much debate, the settlers simply chose to name their post office after the town in New York State from which many of them had originated—East Aurora. In a nod to their exiled Native American friend, they also acknowledged that it was a transliteration of Waubonsie's name, "Dawn of Day." In 1839, Joseph McCarty, the original founder, had moved to Alabama in hopes of restoring his poor health but died in the spring of 1840 from consumption of the lungs (lung cancer). By 1854, West Aurora had risen on the other side of the river, and three years later, the two towns eventually joined as the city of Aurora in 1857.

Barely two decades later, prejudice against the Native Americans turned the memory of Chief Waubonsie's revered reputation into that of a murderous psychopath—and Aurora's light cast its first dark shadow. According to these later sensationalistic sources, Waubonsie had boasted that the origin of his name, "Dawn of Day," came about "because when I kill a man he turns pale; like the first light of day." In his 1877 book *History of Kendall County*, Reverend Hicks, one of the more lurid historians of the Fox Valley area, described Waubonsie as

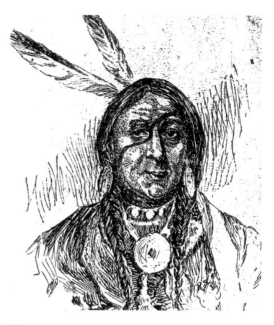

The famous (or infamous) Potawatomie war leader, Chief Waubonsie. *Courtesy Aurora Historical Society.*

a giant in size and a devil in nature. As strong as a grizzly bear, and as ignorant and barbarous as the dogs that followed his ponies, he was dreaded by his people and feared and avoided by the whites. Liquor, no doubt, made him worse, for he drank immoderate quantities of whisky whenever he could get it, but was naturally harsh and vindictive. He beat and murdered his wives so habitually that perhaps it may be said that one of the poor unfortunates was sooner or later left behind in the soil of every camp ground.

More about Chief Waubonsie is discussed in the chapter on Devil's Cave, but the extreme polarity of the impressions he made on the early pioneers underscores the relevance of the old proverb to Aurora's yin-and-yang profile.

This contrast extends into economics, as well. During the hardships of the Great Depression, World War I and World War II when the rest of the nation was literally starving in the streets and rations were at a minimum, Aurora prospered. A manufacturing powerhouse—with the CB&Q roundhouse, multiple heavy machinery foundries, machine shops,

textile mills and breweries—Aurora had all the industries most necessary for wartime. Its residents grew rich, and they were looking for entertainment. Between 1874 and 1938, a total of eleven opera houses and theaters opened to brisk business, along with restaurants, nightclubs, stadiums, parks, circus acts, racetracks and fairgrounds. But decades later, while the nation was giddy about the excessive prosperity of the 1980s, Aurora was experiencing economic meltdown.

Aurora's biggest employers had or were closing their doors for good. Only one theater, the Paramount, had survived. Unemployment in Aurora soared to 15 percent, with the downtown becoming an unsightly ghetto, its streets lined with empty storefronts and filled with bums, prostitutes and drug dealers. Gang crime violence was out of control. Today, Aurora is experiencing a renaissance of beautification, entertainment and civic pride even as the rest of the nation is enduring the worst economic disaster since the Great Depression. But that's Aurora, Illinois, for you...light and shadow, contrasts.

The truth of the ancient proverb is found in the very DNA of Aurora's citizens. Famous notable personages born in Aurora include blockbuster novelist Clive Cussler; Zachary Taylor Davis, the architect of Old Comiskey Park and Wrigley Field; Ruth VanSickle Ford, owner of the Chicago Academy of Fine Arts; Stana Katic, star of ABC's hit television show *Castle*; Henry Gale, astrophysicist; Tom Skilling, renowned meteorologist for the *Chicago Tribune* and WGN-TV; Ira Copley, founder of Copley Press; and Rita Garman, justice of the Illinois Supreme Court. Of equal importance are the many *infamous* notable personages born in Aurora, including Jeffrey Skilling, the former CEO of Enron Corporation; Edna Murray, the Depression-era outlaw known as the Kissing Bandit; Nicole Narain and Kimberly Donley, adult actresses and former *Playboy* playmates of the month nude models; the fictional Wayne Campbell and Garth Algar from *Wayne's World*; and, perhaps the most embarrassing Aurora-born native of them all, Brad Childress, the current NFL head coach of Chicago's arch nemesis, the Minnesota Vikings.

In 1881, Aurora got the nickname the "City of Lights" because it was the first town in Illinois to light its streets with electric lights. But Aurora has also been called the "City of Cemeteries" for the unusually high number of graveyards located here. Aurora's glorious achievements are contrasted by the stark shadows of the many awful events of its past. Some of those events birthed ghosts as well as ghost stories, from firsthand encounters with the paranormal to Aurora's own unique urban legends.

Aurora, the City of Lights…and Dark

 I'm proud to say that this book is the first time that Aurora's ghostly past has ever been thoroughly researched, compiled and published. But Aurora is such a rich treasure-trove of haunted history that I know that there are many more ghosts and ghost stories yet to be discovered. True to Aurora's contrary, contrasting nature, I'm sure that as soon as this book goes to print I'll be inundated with more of Aurora's ghost stories. I certainly hope so! I warmly invite you to contact me if you have a story to tell that combines our local history with our fascinating ghost lore. Happy hauntings!

<div align="right">–Diane</div>

TANNER HOUSE AND
PAYROLL ROCK

It was the evening of October 23, 2006. The geomagnetic field was active. Solar X-rays were normal. The moon phase was one day after the new moon, with disk illumination at 1 percent. It was noted in the field report that this moon was the thinnest crescent in eighteen years. Eight investigators of the Will County Ghost Hunters Association had been invited to partake in an overnight investigation of the William Tanner House, located at 304 Oak Avenue in the historic Tanner district on the west side of Aurora.

The science of paranormal investigation is difficult at best. Ghost hunters use all kinds of measurement and recording devices to capture any hard, solid evidence of paranormal activity and meticulously use established scientific methodologies to document any and all findings. What makes it so difficult is that we don't exactly know what it is we're measuring and recording. Electricity? Ectoplasm? Lost souls? Invisible people? What's the nature of paranormal activity? Why, if it's a natural phenomenon, does it not occur on a regular basis? What possible influences might increase the likelihood that a ghost will appear—solar flares, lightning storms or phases of the moon perhaps? Pinpointing the unknown to hard and fast scientific principles may or may not be an act of futility, but explorers of this realm from all around the world keep trying.

The Tanner House was built in 1857 by William Augustus Tanner and his wife, Anna Plum Makepeace Tanner. He was a prosperous hardware dealer, made rich by selling the necessary tools and equipment the early pioneers needed to make it in this rich new land. They had ten children:

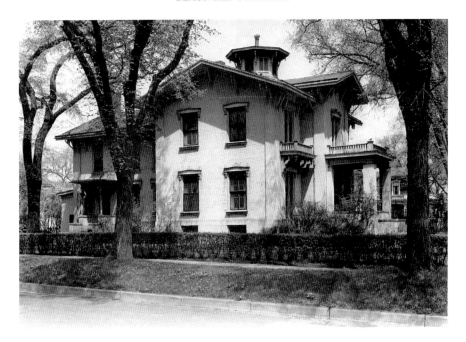

The William Tanner House, circa 1930s. *Courtesy Aurora Historical Society.*

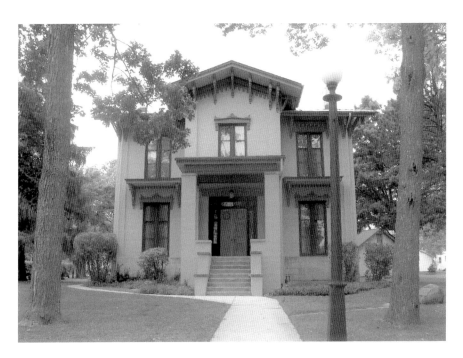

The Tanner House has scarcely changed since 1857 thanks to the devoted care and exceptional restoration efforts of the Aurora Historical Society. *Author's collection.*

Amy, Eugene, Florence, George, Henry, Imogene, Lucy, Marion and the twins Martha and Mary. With the exception of Lucy, who died at age two, the others all survived into adulthood. Of the twelve members of the family, four people died in the house, all of natural causes: William Tanner in 1892, Anna in 1900 and Imogene and Henry in 1934, neither of whom ever married. The two-and-a-half-story brick mansion is an outstanding example of the Italianate style and is laid out in the shape of a Latin cross, with seventeen spacious rooms and an octagonal cupola. In later years, the last of the Tanner children, Mary and Martha, donated their childhood home to the Aurora Historical Society as a museum. It's exceptionally well preserved, and aside from minor renovations the house looks very much like the way it did 125 years ago.

For years, museum employees and volunteers have reported peculiar activity occurring on a frequent basis in the old mansion. An unseen presence has been felt throughout the house. But the key activity seems to be centered in the bedroom at the top of the stairs and the bedroom directly adjacent to it on the west. The latter is currently closed off and used for storage. These bedroom doors reportedly lock by themselves, a phenomenon often accompanied by the strong smell of fresh-cut flowers in the hall just outside the entrance. Clear impressions of a person sitting or lying on the mattress are seen on the bedspread, and noises of someone moving around the room are frequently heard, though upon inspection the room would be empty.

As the overnight investigation progressed, some startling data was revealed. The EMF meters—devices that measure electrical and magnetic fields—showed mysterious energy fluctuations, spiking from a base reading of 0.1 milliGauss to 1.8, though the electricity had been shut off throughout the entire house. Deep impressions over various points on the bed appeared before their eyes several times during the investigation, giving the appearance of someone lying on the middle of the bed and then moving to sit on the side. This strange phenomenon was supported by the noncontact digital laser thermometer showing significant levels of temperature readings up to twelve degrees' difference between the indentations and the rest of the bedcover. Later, during the analysis of their findings, they examined a photograph taken of the bed that had captured what appeared to be a woman wearing a large vintage gown in the act of rising up from a sitting position directly above the hollowed impression on the bed. Lastly, two solid Class 2 EVPs (electronic voice phenomena) were recorded in the bedroom. The first was when the lead investigator, Dan, had asked, "Do you know what year it

is? Today is October 23, 2006. Did you know that?" On the digital tape, a woman's voice is heard clearly saying, "No," but no one heard it spoken aloud. The second EVP was when Dan asked, "Is your last name Tanner?" Again, a woman's disembodied voice is on the recorder but not heard live, answering, "Yes."

The Will County Ghost Hunters Association concluded that reports of paranormal activity at the Tanner House should not be shrugged off. However, none of the activity is threatening in any way and will likely continue for some time. If you'd like to read the full investigative report, visit the association's website at www.aghostpage.com.

PAYROLL ROCK

The large, humpbacked granite boulder on the northeast corner of the Tanner House property has quite an unsettling history associated with it. This rock once sat at Prairie Street and Cleveland Avenue, where an old Indian

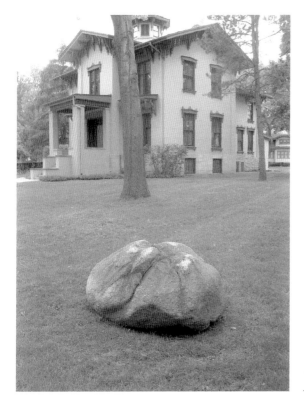

The haunted Payroll Rock at its current location near the Tanner House museum. *Author's collection.*

trail crossed Turkey Creek, a waterway that is now long gone. In 1832, a band of hostile Indians attacked a troop of cavalrymen under the command of General Winfield Scott. They had been escorting the army paymaster on his way to deliver the payroll box filled with silver coins. The soldiers were killed down to the last man—and that last man was the paymaster. But before he died, he dug a hole underneath a large, humpbacked granite boulder and shoved the payroll box deep inside to hide it. Then an Indian brave caught up with him and slaughtered him on the spot.

In spring of 1969, the boulder was moved to its current location on Oak Street at the Tanner House in commemoration of the infamous Turkey Creek (now Prairie Street) Massacre. Unfortunately, it has no marker or bronze plaque to tell its grim story. But who needs a plaque when there's a ghost to tell the tale? Aurora legend has it that the ghostly noises of that murdered soldier's last moments can still be heard on the exact day and exact hour of the massacre's anniversary. The sounds emitting from the base of that rock are of a man gasping for breath while carrying on some kind of frantic activity, presumably digging out a hole with his bare hands. It's followed by a muffled scream of terror and defiance that is abruptly, sickeningly, cut short.

A HELL BECOMES A HAVEN

If the walls of the magnificent pillared mansion at Oak and West Park Streets in the Tanner Historic District could speak, they'd be too choked with tears to express the despair suffered by the women and children who had lived there. Yet those same walls would stand resolute in sheltering them from abusive husbands, boyfriends and fathers.

In 1853, Benjamin F. Hall, the founder of the *Beacon-News* and Aurora's first mayor, built the front part of this historic mansion in the grand Italianate style, featuring a central cupola in the low-pitched roof. Tragically, he was to enjoy its beautiful luxury for only eight years. On a night in September 1860, Hall was a passenger on the *Lady Elgin*, a wooden-hulled side-wheeler steamer headed to Milwaukee, Wisconsin, from Chicago. It was regarded as one of the most elegantly appointed ships to ever ply the Great Lakes. At 2:30 a.m. on September 8, a schooner called the *Augusta of Oswego*, sailing without running lights in gale-force winds, rammed into the *Lady Elgin*'s port side and then limped away into the stormy night for the safe harbor of Chicago. As the *Lady Elgin* sank, flashes of lightning and thunder illuminated the horrifying scene of screaming passengers and crew flailing in the storm-tossed waves, clutching desperately to any of the shattered wreckage that would float. Most victims drowned in the nightmare hours before daybreak, which was the soonest they could hope for rescue. Others were able to swim close to shore only to be pulled under by the breakers and dashed to death against the rocks. An estimated four hundred people died along with Benjamin

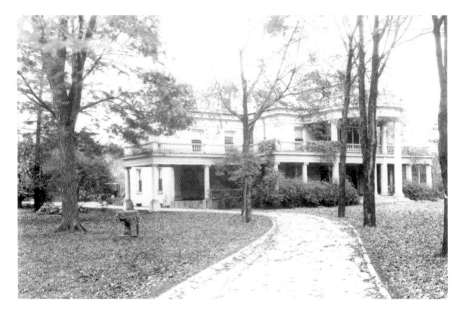

The unhappy home of Captain Charles H. Smith, circa early 1900s. *Courtesy Aurora Historical Society.*

Hall on the *Lady Elgin* disaster, and it remains to this day the greatest loss of life in the history of the Great Lakes.

The Hall mansion was later purchased by Captain Charles H. Smith, who from 1907 to 1910 extensively remodeled it into a Georgian Revival style, adding a matching coach house. Captain Smith made his fortune in heavy machinery, manufacturing the equipment that graded the earliest roads and streets in this entire area. Such powerful, arrogant barons of industry like Smith ruthlessly dominated turn-of-the-century America, and the domination started right at home. With his wife, Selma, Smith had three daughters and one son, also named Charles—the only heir to his empire and the apple of his eye. But the nine-year-old boy contracted pneumonia, and because, as the legend goes, Selma's religious beliefs restricted medical intervention in God's plans, she never called the doctor. Little Charles died, and the captain flew into a furious rage of grief and vengeance. To punish Selma, he had Charles buried right outside her parlor window so that she would be reminded of her tragic decision each and every day. For the rest of his life he abused her—mentally, emotionally and physically—though proper society would never permit his cruelty to be spoken aloud in public. With no record of his abuse, this horrible story of cruelty would have died

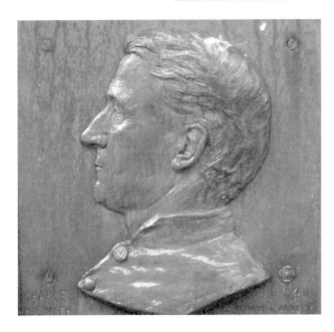

Captain Charles H. Smith. Bronze relief on the Smith family tombstone at Spring Lake Cemetery. *Courtesy John Jaros and the Aurora Historical Society.*

along with Charles and Selma but for the whispered rumors and people's memories of that little boy's sad grave outside the parlor window.

Selma outlived Charles by many years, so she was able to escape his brutality in that way. Sometime after her husband's death, she moved little Charles's body to the Smith family plot in Spring Lake Cemetery, where she later came to rest in peace beside her boy. In 1914, their eldest daughter, Edna, founded the Juvenile Home as a haven for neglected and abandoned children. She had certainly known what it was like to be helpless with no adult to turn to, and her staunch advocacy was a lifeline to many children over the years. Unfortunately, tragedy struck again, and Edna was killed in an automobile accident. In 1944, the last surviving sister and her husband donated the former family mansion to the county Juvenile Protection Agency. In 1948, they named it the Edna Smith Home for Children, dedicated to continuing her efforts to provide a safe and comfortable haven for orphans and children from broken homes.

In 1996, the property was purchased by Mutual Ground, an agency of the United Way, as a twenty-four-hour emergency shelter for victims of abuse. As the first and sometimes only haven in Kendall and southern Kane Counties for women and children suffering from domestic violence and sexual assault, Mutual Ground provides temporary shelter, advocacy, education and counseling. Selma, Edna and her sisters would have wholeheartedly approved.

GHOST CHILDREN

In the Sunday, October 30, 2005 Halloween issue of the *Beacon-News*, popular reporter Denise Crosby wrote an article entitled, "Does One Mother's Pain Still Haunt Mutual Ground?" She interviewed the shelter's legendary director, Linda Healy, about the ghosts that reputedly haunt the mansion. Healy and her staff love their resident ghosts and feel that these spirits are sympathetic guardians watching over the women and children who come to them in need. Besides, these victims have many real-life stories that are far more frightening than any ghostly encounter.

Linda recalled the time when the mansion was undergoing a massive renovation soon after the United Way purchased it in 1996. During an inspection, she saw that the electrical work in the basement was incomplete, so she asked the men to go back down to finish it up. Much to her surprise, they refused her request. When she demanded to know why not, they said it was because of the children down there. She knew that this was an absurd excuse; no one was living in the shelter yet. And if children were sneaking into the house through the basement, couldn't the big, burly workers politely shoo them out or send them up to Linda if they needed help? The workmen hemmed and hawed before reluctantly admitting that while they'd never *seen* children down there, they definitely had *heard* them crying, the heartbreaking sound coming from an empty room. There wasn't enough money in the world to get them back into that haunted basement.

These electricians were the first in a long line to hear disembodied voices and strange sounds in the 160-year-old mansion with the tragic history. Some believe that the distressed spirit of Selma Smith still walks the halls of her home. Others have claimed to see the apparition of a red-haired girl about seven years of age. Had this unfortunate little girl died within its walls at one time, perhaps when it was a home for lost and orphaned children? There's another possibility; it was common for young boys at the turn of the century to have long, flowing hair and to wear dresses, sometimes until they were as old as ten. Could this mysterious red-haired "girl" possibly be nine-year-old Charles Smith, who died in the house and was crudely buried under the parlor window by his father to mercilessly punish his misguided mother?

Whoever the ghost or ghosts are that haunt the mansion, hopefully they're attending the group counseling sessions that have helped to alter the course of so many other lives at Mutual Ground of Aurora, and hopefully these victimized spirits will someday be empowered to finally rest in peace.

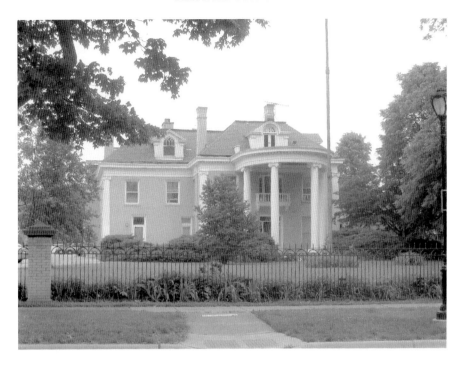

Today, the mansion is home to the Mutual Ground of Aurora shelter for victims of domestic violence and sexual abuse. *Author's collection.*

On a personal note, on July 1, 2009, drastic state and local funding cuts forced Mutual Ground to close its doors. Within the following two weeks, a total of twenty-four women and thirty-two children had come to seek protection—frightened victims of abuse who risked all to escape from the violence in their homes—only to find the emergency shelter closed and locked. On that occasion, director Linda Healy saved the Mutual Ground shelter thanks to last-second grant money from the Dunham Fund and the Fox Valley United Way. In June 2010, Linda retired after twenty-five years, turning the helm over to the capable hands of Aurora native Michelle Curry. But sadly, the current economic crisis has once again put Mutual Ground in danger of closing its doors for good, at a time when violence in the home is skyrocketing from the stresses caused by unemployment and financial hardship. To save the shelter by donating money and time to this much needed "Shelter from the Storm," please visit www.mutualgroundinc.com.

AMERICA'S HISTORIC
(AND HAUNTED) ROUNDHOUSE

The year is 1856. Democrat James Buchanan defeats Whig Party candidate Millard Fillmore to become the fifteenth president of the United States. The newly formed Republican Party holds its first national convention on an antislavery platform. Sigmund Freud, L. Frank Baum, Woodrow Wilson and Booker T. Washington are born. The first kindergarten in the United States opens in Watertown, Wisconsin. Inventor Hamilton Smith is awarded a patent for the first tintype camera. And in Aurora, Illinois, the Chicago, Burlington & Quincy Railroad (CB&Q) opens the largest and one of the first stone railroad roundhouses in America, built for the primary purpose of manufacturing, maintaining and—though it sounds odd to us now—turning steam locomotives around because they could not move in reverse.

The first twenty-two of forty proposed service bays for individual train engines and passenger cars were erected adjacent to the railroad at North Broadway and Spring Street, on the east side of the Fox River. Each bay was designed as a parallelogram, measuring twelve feet wide at its inner doors and flaring out to twenty-two feet wide on the exterior walls. To make repairs to the undersides of the locomotives, men would crawl through trapdoors spaced along the inner ring that opened to tunnels that connected all the deep pits in the bay floors. The first bays were forty-five feet in length—sufficiently long enough to house the steam engines of the day. But in 1859 the next eight bays required an additional five feet of depth when cowcatchers were added to the front of locomotives to plow snow and nudge

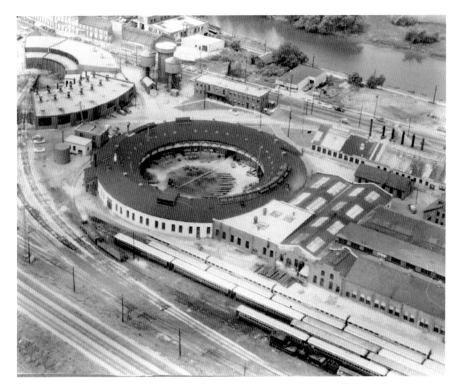

An aerial view of both roundhouses, circa 1950s. Highways and airplanes would soon bring about the decline of the railroad industry. *Courtesy Scott Asher and America's Historic Roundhouse Archives.*

aside such common obstacles on the prairie as stubborn cows and irritable bison. The final ten bays were completed in 1866. After eight long years, all forty bays were finally nested against one another to form a complete tetracontagon—essentially a hollow polygon ring with a massive turntable at the center to slowly spin the engines to point in the right direction.

Between 1863 and 1923, more buildings were constructed around the roundhouse so that the entire yard spread out over seventy acres. This included a twenty-five-stall brick roundhouse, a new train depot at LaSalle and New York, two fireproof buildings, an engine house, a new coalhouse, an electric powerhouse, numerous smaller workshops and a 701-foot-deep artesian well. The second roundhouse was replaced in 1918 with an open, half-moon brick structure.

The Aurora CB&Q Roundhouse was the economic king of the county, employing an estimated 2,400 workers in its heyday in 1910. It was dangerous,

hard and sometimes deadly work, with men laboring twelve hours a day, six days a week. Just how many lives were lost in the roundhouse is unknown to this day, but no one doubts that blood was spilled and that people died from countless horrifying accidents. Certainly there were men who were crushed under tons of cast-iron machinery, burned from forges blazing with molten steel and brained if they weren't quick enough to dodge the engine parts that were moving overhead, precariously suspended from cranes. Cemetery records show where severed arms and legs had been buried years before the roundhouse employees they belonged to had died.

Starting in the 1920s, America's obsession with the automobile brought about the twilight of the once mighty railroad industry, with its final death knell sounded by the dawning era of the airplane. The constant ringing of hammers slowed and finally stopped in March of 1974. By the end of 1976, the Burlington Northern Railroad had completed demolition on all the buildings in the entire seventy-acre yard—except for the old limestone roundhouse and adjacent machine shops. Nostalgia and patriotism proved stronger than the wrecking ball. America was celebrating its 200th birthday that year, and bicentennial fever was running high. The planned destruction of a building that had played such a central role in our nation's storied past was unthinkable. Responding to the outrage of its citizens, the City of Aurora purchased the property and its surrounding buildings—and the roundhouse was spared.

But just like the morning after any wild party, once the thrill of the bicentennial was over people began to wonder why they had bothered to save it. For twenty more years, the old limestone roundhouse slowly decayed into a crumbling, derelict ruin, a neglected eyesore along the riverfront and a creepy initial glimpse of Aurora for visitors riding the commuter train. From the 1970s to the mid-1990s, the massive hollow ring lay abandoned except for rats, bats, gangs, drug users, drifters riding the rails, neighborhood kids who made it their playground…and, oh yes, countless numbers of restless phantoms that lingered in the gloomy shadows, still working eternally long hours and still devoted to keeping the long-vanished iron horses running strong.

"THE DEVIL'S IN THAT HOLE"

For the twenty or so kids in the neighborhood on the east side of the tracks from the roundhouse, the abandoned building was a playground heaven. The hollow ring became their personal sports stadium, and they would spend their summers riding their bicycles around and around the dimly lit

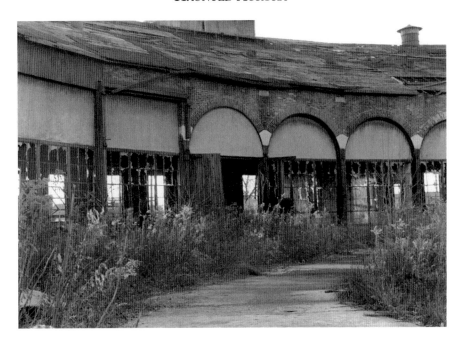

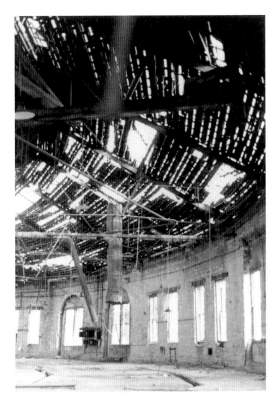

Above: The bay doors of the roundhouse in 1995 before Walter Payton's multimillion-dollar restoration. *Courtesy Scott Ascher and America's Historic Roundhouse Archives.*

Left: This 1995 photo shows the cast-iron trusses and pine beams that supported an overhead system of cranes to move heavy equipment—a workplace hazard. *Courtesy Scott Ascher and America's Historic Roundhouse Archives.*

"racetrack," dodging fallen beams, rubble and broken machine parts left to rust in the cool, damp shadows. Like any intrepid gang of adventurous kids, they would pick through the debris for hidden treasure. Especially prized were the steel ball bearings they called "steelies" that acted as weapons of annihilation in their highly competitive games of marbles played in the sun-drenched central courtyard where the turntable used to revolve with an engine on its track.

One of those lucky roundhouse kids was Aurora native Les Bubolz Jr., whose warm nostalgic memories also included a host of bone-chilling incidents with the paranormal at the roundhouse. Strange sounds were commonly heard from no source they could track: hammers ringing on iron, heavy-soled footsteps, the rumble of invisible trains and, perhaps most disturbingly, disembodied voices emanating from empty rooms. The children frequently glimpsed dark entities walking along the vast, high-ceilinged inner ring or slipping through closed doors even in broad daylight. Objects would vanish from the position where they had lain for decades only to turn up later, mysteriously, on the other side of the building.

One such notable incident was a twenty-year mystery for Les until just recently, when he finally got the entire frightening story directly from the source. Les clearly remembered the events of that beautiful summer's day in 1974 when the whole gang was playing at the roundhouse, which they called the Pit. Their parents had frequently warned them to never play at the roundhouse—it was a dangerous place, and they'd be trespassing on private property. So when the parents asked where they were going to play for the afternoon, the kids knew to tell them, "We're going to the Pit, down by the river." The parents would be reassured, and the children were glad that they didn't tell a lie…technically speaking.

Among the many hazards of the abandoned roundhouse were a number of squared-off holes in the flagstone floor, where the mechanics could drop down to work on the trains from below. Tunnels connected the holes to one another to enable the workers to get out from underneath the massive locomotives by crawling to another bay. One particular hole on the west side was not like the others; the mouth was the length and width of an automobile, and it was so deep that they couldn't see the bottom even with a flashlight. They knew that water was down there because they would toss rocks and "steelies" down and count—"*one*-one hundred, *two*-one hundred"—until they heard a splash far below. The children didn't know it, but this hole was an artesian well, dug in the boom years between 1863 and 1923—an unprotected, unmarked well that plunged 701 feet straight down.

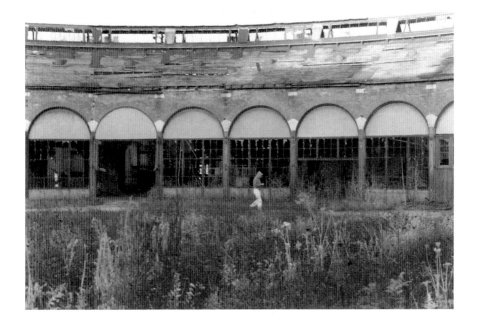

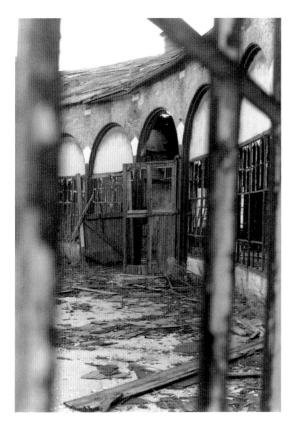

Above: Despite its derelict state in 1995, Walter Payton and Scott Ascher saw the excellent potential for the roundhouse as Aurora's premiere hot spot for entertainment. *Courtesy Scott Ascher and America's Historic Roundhouse Archives.*

Left: Even in daylight, the old roundhouse had a gloomy aura of shadows and ghosts. Shown are the bay doors in 1995. *Courtesy Scott Ascher and America's Historic Roundhouse Archives.*

The young boys used to scare the girls in their group, as well as themselves, with stories that it was the entrance to hell and that demons, monsters and vengeful ghosts lurked in that gaping hole hungry for human flesh and souls.

On that memorable day, Les, who was thirteen years old at the time, recalled that they were all hanging around the turntable pit in the courtyard when one of their friends, whom we'll call "Brian," suddenly burst out from the shadows at the west side of the building, running like he was on fire. His face was stark white with fear, eyes bulging wide, and he was too far beyond terror to even scream. Brian grabbed his bike from the bottom of the pile of kids' bicycles, forcefully ripped it free from the entangling wheels and handlebars and then took off on his bike "like a rocket for home," said Les. Thinking that Brian had been chased away by a railroad worker from over by the depot, the teenagers scattered and eventually regrouped in Brian's backyard. Strangely, Brian refused to come to the door to tell them what had happened to him back in the shadows. Stranger still, Brian swore that he would never again go back to the Pit, saying only that "the devil's in that hole!" He never explained what he meant by that—and he never did return to play in the roundhouse.

Twenty years passed, and one evening Les was pleasantly surprised to bump into his old friend Brian at a local store. They hadn't seen each other in all that time, so they adjourned to a nearby bar to swap stories and reminisce on the good old days. Eventually, the talk turned to the roundhouse, and Les took the opportunity to ask Brian yet again what had happened to him that made him tear out of the building and never go back? And just what had he meant by, "The devil's in that hole"? Brian's face turned pale, and at first Les thought that he'd avoid the topic as he'd done so many times in the past. But to his surprise, Brian reluctantly told Les the full story.

On that summer day in 1974, as the whole gang was playing at the roundhouse ruins, thirteen-year-old Brian decided to play a trick on his friends. While everyone was gathered in the courtyard, he lay down on his belly across the twelve-inch concrete lip of the mysterious hole and carefully inched his way forward until he was hanging well over the edge, looking down into its black depths. It was in his mind to climb down into the hole, wait until his friends walked by and then jump out to scare the pants off them…a profoundly idiotic thing to do, Brian admitted, but like all teenagers, he believed that he was invulnerable to the consequences of his own recklessness.

Brian spent about a half-minute peering around the dark walls of the hole around him for some kind of ledge or protruding stone to stand on—when

suddenly a man's snarling, twisted face appeared down in the gloom, rising up out of the pitch-black depths and stopping just inches away from Brian's nose! Brian had no recollection of how he got home, except for the vague knowledge that he was moving so fast it felt like flying. But the man's furious face was burned into his memory. He told Les, "His face was demonic. It gave me nightmares for months afterward. Even now, twenty years later, I can see it, and it still freaks me out. It's still so clear in my mind I can describe exactly what he looked like. No other time in my life, either before or since, has ever scared me more than that minute when I was face to face with the devil."

What rose up from the watery depths to frighten a reckless young teenager as he precariously leaned over the brink of that abandoned well? Was it the devil, as Brian believed? Or could it have been the ghost of a former roundhouse employee—maybe one who had fallen to his death in that hole sometime in the past century and whose phantom now was furiously angry to catch a young man committing the same foolhardy act that had horribly ended his life? History is disturbingly murky about workplace accidents, since the mighty industries of the day had the power to hush up such needless tragedies, and employees shrugged it off as just another hazard of the job. Instead of the devil trying to drag Brian down into the pit, perhaps it was a ghost trying to save his life.

Today, the well and all of the squared-off holes are bricked over and sealed. Any lingering presence that once haunted that well is at peace, no longer needing to guard the living from their own irresponsible carelessness. No one has peered down into its depths or crawled along the tunnels for many years—no one alive, that is. Or perhaps it would be more accurate to say no *thing* alive. For when Les asked if Brian would be willing to let a police sketch artist buddy of his try to draw the nightmare face he had seen rising up from that black pit, Brian only shuddered. "I don't even want to think about it, man. No way. The devil's in that hole."

SOMEBODY'S BEHIND YOU...

Though Aurora's patriotic citizens had rescued the roundhouse from demolition in 1976, in February 1977 the Burlington Northern Company began to secretly tear down the roundhouse from the inside, starting with part of the east inner wall and roof. But demolition was halted as soon as the city got wise to its sneaky attempt. This was the oldest section of the roundhouse—the original twenty-two bays plus the metal forges, built more

than a century and a half ago in 1856. Due to the clandestine demolition efforts, the roof drooped to the ground as if a giant had sat and leaned back on it like a lounge chair. Only a small area remained open and accessible beneath the shattered remains; it's in this perpetually dark and gloomy part of the ruined roundhouse where the greatest number of frightening paranormal encounters have been reported, even to this day.

Les Bubolz recalls one particular spot in that area that was always inexplicably chilly, even on the hottest summer days. When they would race their bikes around and around the ring, they would actually look forward to speeding through that strange cold spot for a little relief from the sweltering heat. But no one would stop to enjoy its cool shade, because there was something about that spot—something that made the hair on the back of a teenage boy's neck stand up straight and that made him catch strange shadows moving out of the corners of his eyes—that discouraged anyone from lingering there for very long. Even the few men who still worked at the Burlington Northern train depot nearby wouldn't enter that troubled area.

Late one autumn afternoon in the late 1970s, Les's high school friend "Gary" brought his girlfriend "Liz" to this quiet, private spot for a little romantic rendezvous. The sun was setting, and though the central courtyard was still illuminated with the red light of dusk, the shadows under the demolished roof were darker than ever. The couple smoked and shared a beer he had stolen from home and then got down to some serious kissing as twilight fell. As usual, the roundhouse was empty of loiterers at that time of night, and a soft wind rustled the dry grass and dead leaves out in the courtyard, though the air under the fallen roof was perfectly still. Gary paused long enough to light a kerosene lantern he had brought along, but they both failed to notice that the flame didn't penetrate the dark as brightly as one might expect—as if the black shadows had a thick, heavy density that smothered the light.

They were sitting side by side in each other's arms. Liz was nuzzling Gary's neck, her lips soft against his skin and her fingers buried in his hair. Gary was in heaven. Deciding that the time was right to steal the next base, he pulled away for a moment so he could gently lay her down on her back, smiling at her in what he hoped was a reassuring, loving manner as she gazed up at his face and smiled warmly back at him. Then Liz briefly looked up over his shoulder as if she had been distracted by something moving behind him.

Gary later swore that, even if he lived to be one hundred, he would never forget what happened next. Suddenly Liz's eyes widened until the whites showed completely around her irises. Gary saw the blood drain from her face and felt her suddenly cold hands gripping his scalp like icy claws as

her entire body froze with terror in his arms. Liz didn't scream—she only made a tiny, garbled, whimpering sound before she ripped away from Gary's embrace, scrambled to her feet and *ran* out of the caved-in area, through the courtyard and out of the roundhouse door.

Bewildered, Gary sat on the dirty concrete floor and stared after her. It was only then he realized that the temperature around him had plummeted by at least twenty degrees in the last few seconds and that the flame from the kerosene lantern had dimmed, as if muffled by the darkness. He felt the tiny hairs on his body stand up at attention as a wave of gooseflesh prickled his skin; the unnerving, undeniable sensation that *someone* was standing at his back, looming over him in absolute silence, scared him out of his wits. Gary scrambled up and flew after Liz, his feet scarcely touching the ground. He was too panic-stricken to even look back over his shoulder to see who—or what—had been standing behind him in the dark, haunted ruins.

Gary came back the next morning with the sun shining brightly overhead and several friends in tow. They found the kerosene lantern exactly where he had left it, the wick burned down to a mere glow with the last of the oil. He went to Liz's house to check on her and to ask what it was that she had seen over his shoulder last night. He figured that Liz would say she saw a Burlington depot employee taking a shortcut home though the roundhouse after working late. Or maybe she saw some drifter attracted by the lantern light and hoping for a handout. Gary certainly didn't expect that she would refuse to tell him what she saw. No matter how hard he pleaded, Liz would only shake her head no, her arms crossed tightly around her, her face white with fear and tears in her eyes. All she ever told him was, "If you love me, you'll never go back there again." Gary protested long and loudly. All of his friends hung out all the time at the roundhouse. It had been their favorite hangout for years; how could she even ask that of him? Liz didn't relent an inch. "If you love me, you'll never go back." Their relationship lasted for one week before they broke it off, and Gary started to hang out with his friends at the roundhouse again. But Gary never again stayed past sunset and never stepped into the cold, heavy shadows under the collapsed roof in the oldest part of the building.

"GET. OUT."

Gary and Liz weren't the only ones to have their nerves shaken in that particular section of the building. Les Bubolz had his own weird experience that he'll never forget. Spooky though that cave-like area was, it was a rich source of "steelies,"

so prized for their marbles games, probably because it had once been where the metal forges burned endlessly. Late one afternoon, Les and a friend were searching for steelies. He had just spotted a nice one gleaming in the rubble and had bent to pick it up when a man's voice came from behind him. "Get out."

The voice wasn't scary or threatening, Les recalled. Instead, it sounded matter-of-fact and perhaps a little bored. Les straightened up and looked around, thinking that it had been his friend who spoke and wondering why he wanted him out of there. But he spotted his friend far down the corridor, preoccupied in his search for his own steelies, so it couldn't have been him talking. Les shrugged—it was just another oddity in a long line of weird incidents at the roundhouse—and bent down again to pick up the steelie. The voice said it again, more firmly this time and with that precise, two-word emphasis that meant he wasn't kidding: "Get. Out."

Les bolted upright and nervously looked all around him, but no one was there. He was alone in the darkest, most haunted part of a very haunted building, and somebody didn't want him there. Keeping his cool, Les walked out from under the collapsed roof and into the sunshine—very, very fast.

Ghost Train

Another unforgettable brush Les had with audible paranormal occurrences in the roundhouse took place one night in the courtyard immediately in front of the tumbledown roof. This time, however, he had two witnesses who also experienced the chilling phenomenon and could back up his story, though Les admitted that one of those witnesses couldn't be considered a reliable source due to his fondness for smoking a certain variety of weed (hint: not dandelions). This rather hazy witness, however, had an entertaining, Woodstock-veteran charm, so when he suggested that Les and a friend hang out in the roundhouse courtyard with him at sunset, "to hear something amazing, man," they gladly agreed.

Les assumed that his hippie friend was going to play his latest composition on the guitar for them. But almost as soon as they settled themselves comfortably in the turntable courtyard, he began telling them about the fascinating yet mysterious sound he'd often heard in the roundhouse—a particular sound that seemed to come from nearby yet at the same time was from nowhere on this plane of existence. That's why he had asked Les and his buddy to join him there at the desolate roundhouse. He figured that if they all heard the noise, then he'd know that it wasn't a figment of his fogged imagination.

"Man, let's just sit and listen," he said, telling them to relax and tune in to the universe. In comfortable silence, they leaned back, waited and listened, watching the stars peek out one by one as the sun set into twilight. Perhaps a half-hour passed before Les noticed that the ground was lightly trembling beneath him, and they could hear the deep rhythmic rumble of an approaching train. At first, they didn't think anything of it—after all, the train tracks went right past the roundhouse. But then they remembered that it was Sunday; the commuter trains were running on a limited schedule. Having lived by the tracks all their lives, the young men knew the train schedule by heart. They knew that the 7:46 p.m. train had pulled into the Aurora depot just fifteen minutes ago and that the next one wasn't due for another two hours. Furthermore, it didn't sound like a commuter train. This engine was much heavier, ponderous, crafted of dense iron instead of the streamlined materials used in today's modern train engines.

The sound grew thunderous and the trembling intensified, and the three young men were alarmed to realize that this mysterious train wasn't going past them on the tracks outside of the roundhouse walls—this train was heading straight toward them, coming *inside* the roundhouse! Steam hissed like the brakes of an old-fashioned steam locomotive and an iron bell clanged in warning, the sounds echoing with a peculiar resonance. Now the earth shook violently beneath them, and the rhythmic rumble of iron wheels became an endless, ear-splitting roar of thunder. A great gust of cold wind suddenly blasted them with the strength of a passing invisible train, and that did it for Les and his two friends! They got up and ran out of the roundhouse, even as the sounds of the ghost train abruptly stopped at the height of its volume, as if it had vanished into another dimension.

As they stood panting by the road in adrenaline-fueled fear, their hippie friend turned to them with wild eyes and said, "That's what I've been hearing at the roundhouse these past few nights! Did you hear it too? Or was I just high?"

Les never heard the ghost train again after that heart-pounding Sunday night one hour after sunset. And though he can't even begin to explain how it happened, he is dead serious when he swears that it really did happen.

OUT FOR A SPIN

The neighborhood kids weren't the only ones who had surprising encounters with the paranormal during the decades when the roundhouse stood empty. Plenty of other people had, at one time or another, witnessed weird activity

there that couldn't be rationally explained. "Jim" was another longtime Aurora resident who had his own uncanny tale to tell. It occurred back in the 1960s. It is important to note that this event happened not at the historic old limestone roundhouse, but rather at the brick roundhouse just to the south of it. This building was a fourteen-bay, half-moon semicircle built in 1918, complete with its own turntable.

Jim's father had a good friend who was one of the last men employed at the train yards as part of a forty-three-member crew. They worked two shifts every night from 4:30 p.m. to 7:30 a.m., servicing all of the suburban and mainline engines in and out of Chicago and handling nineteen to twenty-one diesels nightly to keep them all running smoothly for the hordes of daily commuters. Many of these men lived like homeless vagabonds, eating and sleeping during the days in old wooden boxcars put out to pasture long ago in the train yard.

One bright day, Jim's father had some business to attend to with his friend, so Jim went along to keep him company. While his dad was chatting in the yard, Jim decided to explore the area. He eventually wandered into the central courtyard of the half-moon brick building with its massive train turntable. "Turntable" is a somewhat misleading term, in that it was not a level, round disk like an old record player. A typical roundhouse turntable was a single-track train rail slightly longer than the average diesel engine. It sat above a circular pit that housed the mechanism that would rotate the platform and its massive burden until it would point toward any one of several connecting tracks that radiated out from the circle and led into the various bays. At the time of Jim's story, the brick roundhouse had the only operational turntable, since trains were no longer hauled into the old limestone roundhouse. Since the 1920s, the original building was used only to manufacture engine and passenger car parts. Its turntable had been completely taken out in 1927.

To Jim, the turntable track at the brick roundhouse was like an enormous carousel—and what boy could resist playing on that? Jim hopped on the turntable track and immediately tried to get it to move by throwing his weight from one foot to the other. He might as well have been a gnat trying to move a merry-go-round; it didn't budge. He kept trying, however, pushing with one foot on the ground and the other one on the rail, rocking from one side to the other and even climbing down and shoving it with his hands.

Jim's dad called for him to come out of the brick roundhouse; it was time to go home for supper. Just then, the huge old turntable suddenly shuddered under Jim's feet; with a rusty iron groan, it gave a lurch and began to move! Thrilled, Jim started to walk up and down the length of the slowly revolving

platform, his dad's call forgotten. It steadily gained speed, and Jim walked a little faster, grinning with delight. The turntable spun faster and faster and faster, inexplicably picking up speed with every revolution. Now Jim was no longer smiling; instead he was scared as he braced his feet on the turning track and held out his arms to keep his balance, desperately trying to not be thrown off by the centrifugal motion.

Suddenly, his dad ran out into the courtyard and grabbed his son off the wildly spinning turntable, whisking him to safety. Like a rodeo bronco that succeeded in bucking that irritating cowboy off its back, as soon as Jim's feet left the track it started to slow down, until it eventually ground to a halt. The railway workers were just steps behind Jim's dad, and while they were relieved to see that the boy was all right, they were angry that this mischievous child had obviously gotten into the electrical closet and threw the switches that operated the turntable. That closet door was supposed to be locked at all times, and the friend of Jim's father had the only key. He insisted that he hadn't opened that door at all since Saturday morning and was genuinely alarmed to think that perhaps he hadn't properly locked it that last time. They all trooped over to the electrical closet, only to be shocked to the core to find that the closet door was locked tight…with dust lying undisturbed on the doorknob.

ALL-AMERICAN HERO SAVES AMERICAN LANDMARK

In 1994 a true blue all-American hero visited the decaying roundhouse. He weaved among the obstacles of rubble, trash, discarded needles and rusted out rails; danced around gaping holes and oily puddles dripping with rainwater from the broken roof; moved through the cold shadows that seemed to fall back from his presence; and fell in love with the crumbling old wreck. He was Walter Payton, the all-star running back of the Chicago Bears football team from 1975 to 1987, a nine-time Pro Bowl selection and winner of multiple MVP and Player of the Year awards, the NFL Player of the Decade, champion of Super Bowl XX, Hall of Fame inductee—the list of honors goes on. In his thirteen years as a Chicago Bear, Walter Payton set sixteen NFL records, including that of all-time leading rusher with a remarkable 16,726 total yards. Famed Super Bowl Bears coach Mike Ditka once said that Walter was the greatest football player he had ever seen but that he was even greater as a human being.

Walter's single-minded resolve to give his all in everything he believed in, both on the field and in life, was legendary. His personal motto was "Never die

easy," which he attributed to his college football coach at Jackson State. It meant that he never deliberately ran out of bounds and refused to be taken down by tacklers without a hard, painful fight. As one defensive tackle on the Minnesota Vikings once said of Walter, "Once you got ahold of him, you weren't sure you should have." Walter awed his fellow athletes by his determination to keep on playing even while sick or injured. The most notable example of his astounding perseverance came on November 20, 1977, in a game against the Minnesota Vikings, when Walter rushed for 275 yards on forty carries, shattering the previous record set by O.J. Simpson while sick with the flu! He missed just one game in his entire professional career, and that was in his rookie season of 1975 when an assistant coach had to sternly order him to sit out the game after suffering an injured ankle. True to his motto, that solitary mark on his otherwise perfect attendance record rankled Walter for years afterward.

His soft soprano voice and gentle-hearted personality gave Walter his nickname, "Sweetness," though some people claimed that it was more of a wry description of his aggressive, never-die-easy style of play. He was also called the "Dancing Bear." With his natural athletic grace and amazing gyrations on the field, no one was at all surprised to see him dancing some fine moves in the 1985 music video *The Super Bowl Shuffle*. What many fans didn't know was that Walter once appeared on the Chicago-based television show *Soul Train* in 1972, winning second place in the couples dance contest. He often joked that he "should've finished in first, but my dance partner wasn't that good. But that's the same story *she* told everyone."

Walter's sense of humor was as famous as his legendary determination. A practical joker, he was known to untie the referee's shoes while in a pileup over the football, hook a finger in the pants of a lineman so he'd slip out of them at the snap of the ball and rush into the locker room after games to lock his teammates out in the cold while he enjoyed a long, hot shower.

Walter Payton's winning personality, superstar status and never-die-easy attitude assured his financial success after his retirement from football in 1987. Among his many business ventures, he was an investor, speaker, restaurateur, nightclub owner and entrepreneur and drove racing cars as co-owner of Dale Coyne Racing. But out of all his many successful enterprises, restoring the old Aurora Roundhouse into a flourishing entertainment complex was perhaps his most gratifying accomplishment.

At the time when the old roundhouse was first brought to his attention, Walter and his business partners, Mark Alberts and Scott and Pam Ascher, were considering opening up a restaurant called Island Hoppers in Maui, Hawaii. But after the City of Aurora presented them with an offer they just

couldn't refuse, the choice was an easy business decision: either pay $360 per square foot to rent in Maui or pay just $10 to purchase the entire roundhouse building and 4.15 acres of property. (No, I didn't leave a few zeros off that number; the purchase price really was ten whole dollars.) The city was desperate to see the long-neglected property transformed into a successful tax-generating retail business venture, but of the several development plans that had been unveiled, none had came to any fruition until the Payton/Ascher plan. Though it was primarily an economic decision, Aurora residents still like to brag to this day that our city was chosen over a tropical paradise.

Restoration of the old ruin began on March 17, 1995, and on March 21, 1996, it was opened as Walter Payton's Roundhouse Complex. The self-contained entertainment complex featured a restaurant, a brewery, a comedy club, banquet and conference rooms, a sports bar, a cigar and cognac lounge, a Walter Payton museum and a beautiful courtyard pavilion perfect for live music and dancing under the stars—the same courtyard where massive steam locomotives once spun majestically on a turntable in a dance of their own. In a nod to its original heritage, the north side of the Roundhouse is still a stop on the Burlington-Northern commuter railway from Chicago's Union Station—or, as the advertising for our Historic Roundhouse Ghost Tours ominously says, it's the "End of the Line." Out of all his nightclubs in the Chicagoland area, the Roundhouse was Walter Payton's favorite. Not a weekend went by that Walter wasn't found shooting pool and dining with the customers, drinking his award-winning Payton Pilsner beer, smoking cigars in the lounge and dancing the night away to the music of live bands. Walter Payton's Roundhouse Complex was his pride and joy.

But soon after its grand opening, employees began to experience strange things that they couldn't explain. It only took one night alone in the huge stone building for the brewmaster to refuse to stay so late by himself ever again. He said that he had heard too many strange noises and saw shadows that he simply couldn't explain or find the source of. "It's fine as long as there are people around, or if it's daylight. But you can't pay me enough to stay overnight alone in a haunted place."

THE SHADOWMEN

Restorations and other extensive repairs of any building can often be catalysts for paranormal activity, as if the spirits are disturbed by changes to their home. The Roundhouse was certainly no exception. No sooner was

the massive reconstruction project underway than workers and later the employees began reporting seeing human-shaped shadows moving where no shadows could have been.

These shadowmen were most commonly seen in the curving limestone corridor on the second floor outside the Stout and Lager conference rooms, above the banquet hall. This was the oldest part of the original 1856 building, what had been the first bays and forge. Just like the neighborhood children and railroad workers had discovered for themselves decades ago, it quickly gained the reputation among employees for being the most haunted area of the entire Roundhouse. Even today, the strong aroma of molten metal and burning coal has been reported in one spot in the banquet room, only to fade away within a few moments. But there was no second floor until the late 1990s; how could the upstairs corridor be so haunted? One theory is that limestone is an excellent battery for paranormal energy, retaining and replaying the lingering signatures of ghosts in each stone block. The

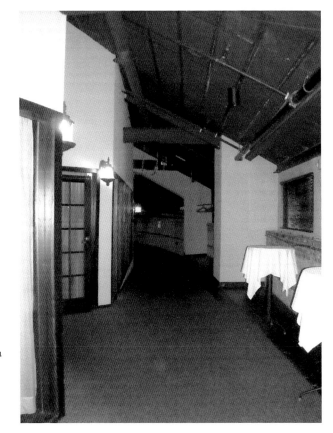

This corridor outside the Stout and Lager conference rooms has a reputation for shadow figures, rappings, weird EMF spikes and disembodied voices. *Author's collection.*

second floor above the banquet hall may have ghostly activity because it was constructed from the same limestone blocks and rubble from the original demolished—and very haunted—building.

This last fact may also explain a creepy architectural attraction found in the upstairs Stout Room. An old wooden door and two windows open out into the room, looking for all the world like the front of a small cottage. But watch that first step! This "cottage" is placed high in the truss of the pitched ceiling over where guests line up for drinks at the bar. It's reminiscent of the famous Winchester Mystery House in San Jose, California, purportedly designed by spirits of the dead to include interior windows and a "door to nowhere" that opens from the third floor into midair. Who fitted the Stout Room with this dark wooden door and pair of windows up there by the ceiling is a mystery. It wasn't in the architect's design, and even co-owner Scott Ascher hadn't been aware of it until much later. But suspicion points to Walter Payton—it carries all the hallmarks of his trickster sense of humor.

Scott Ascher had a personal encounter with an unexplained shadowman in that limestone corridor during the earliest restorations. He and Armando Renovato were pouring a concrete ramp on the second floor. Suddenly they both noticed a strange shadow on the limestone wall just five feet from where the ramp was being poured. It looked like a man, and he assumed it was either his or Armando's shadow, but something about it struck Scott as unusual. Just then, the answer came to him: where was the light coming from that could possibly cast this shadow at this particular spot? Scott waved his hand, but the shadow was motionless. It wasn't Armando's shadow, either. Intrigued, for the next few minutes they experimented with the light to see how it could possibly cast such a peculiar, man-shaped shadow, without success. No matter how they moved the light or blocked the light, the shadow remained. Finally, Scott and Armando turned off the lights completely and then quickly turned them back on—to their surprise, the shadow figure was gone! They simply shrugged it off as a mystery and got back to work, though they were quick to finish up and leave early for the day.

On weekends, the director of operations, Chela Tovar, works late at night into the early morning hours at the Roundhouse. She's had countless weird occurrences and takes them in stride, though she still refuses to walk down the conference room corridor alone by herself at night. When she must, she'll always ask a few men of the kitchen staff to walk along with her. But her most unforgettable encounter was not in that mysterious corridor, but rather at the main entrance of the restaurant. It was in the winter of 1997, and she was busy closing down the building for the night. The only people

left in the Roundhouse beside herself were two male workers in the kitchen, located in another part of the building.

Chela was on the loft above the main bar that overlooked the main entrance with its flagstone walkway, host stand, waiting area and coffee bar that serves commuters on their way to the train in the mornings. The only lights were cast by small overhead lamps spaced widely apart, the dim pools swallowed up by vast expanses of deep shadow along the corridors. It was after 3:00 a.m. and all was quiet at this darkest and coldest hour of the night—the hour when more people die than at any other time, the hour when the dead walk. Children are afraid of the midnight hour, but adults fear 3:00 a.m. with an instinctive dread that leaves the human soul feeling utterly alone on sleepless nights.

Suddenly, the eerie quiet was broken by what sounded to Chela like heavy footsteps on the flagstones of the main entryway. It was a dull, thudding, scuffling noise that grew louder and more distinct, as if more people had joined the first group. Curious and wary, since she knew that the front doors were locked and that no one else was around, Chela moved to the balcony rail and looked down into the entryway. To her astonishment, she saw dozens of gray, shadowy figures shuffling from the front entrance to the door leading to the outdoor patio. A low murmur of male voices, like far-away echoes, rose up from the shifting, moving mass, though she couldn't make out a single word. As the steady stream of ghostly people passed through the closed doors of the patio, they vanished, even as more forms came drifting in the front entrance. The stragglers at last disappeared into the courtyard, and the eerie silence returned.

Chela was finally able to take a breath. She didn't know how long the parade of wraiths had lasted, but it was long enough that she was gasping for air—perhaps a minute or more. Had Chela witnessed the ghosts of long-dead CB&Q employees coming in for the late-night shift? Had time somehow rolled back to provide her with a mundane glimpse of the normal roundhouse routine of one hundred years ago? Some believe that ghosts are generated from the most powerful of human emotions at the moment of death. But other ghosts appear to be simply recorded moments of time played over and over again when the conditions are just right—events that occur so often that they're somehow magnetized into the stone, iron and wood of a structure like sights and sounds are captured on a videotape or audiocassette. You have to wonder: what routine acts of your day are being recorded by your environment right now to become the ghosts of the future long after you're gone?

In 1999, Walter Payton's Roundhouse Complex was selected by the National Trust for Historic Preservation in Washington, D.C., as an "American Treasure," along with thirteen other sites across the nation, including Grand Central Terminal in New York City and the San Francisco City Hall. This prestigious honor recognizes "exceptional achievement in the preservation, rehabilitation, restoration and interpretation of America's architectural and cultural heritage." Richard Moe, president of the National Trust, declared at the dedication ceremony, "Not only have Walter Payton and his partners saved an irreplaceable part of our past, they have also shown how historic structures can be reused in almost any capacity. Now the public can see and enjoy this local treasure, this model example of successful preservation."

"I WANT TO BE REMEMBERED AS THE GUY WHO GAVE HIS ALL WHENEVER HE WAS ON THE FIELD"

It was in February 1999 when Walter Payton announced the fateful news—he had been diagnosed with primary sclerosing cholangitis, a rare autoimmune disease of the liver that inevitably led to bile duct cancer. He could have easily used his fame to go to the top of the list of organ transplant recipients, but he refused, insisting that he was no more in need than any other liver transplant hopeful. Privately, though, Walter knew that his odds for a successful transplant weren't good, since his illness was already far too advanced. Walter Payton died on November 1, 1999—All Saints Day—from complications brought on by his cancer. "Never die easy" never meant more to him than in his last months of life. Just as he had done innumerable times on the field when finally caught by a tackler, Walter gave cancer as much punishment on his inexorable way down as the disease gave him—and it's still going on today. Despite the increasing exhaustion and pain of his failing body, Walter appeared in a number of commercials and public speaking events, becoming the nation's voice in raising awareness for the urgent need for organ donations. Along with his newly established Walter and Connie Payton Foundation, he was the driving force behind the phenomenal skyrocketing of organ donations. Prospective donors overwhelmed regional organ banks with calls.

It is because of Walter that the State of Illinois started adding organ donation request cards in vehicle registration notices to make it easy to become a donor. Thirteen thousand people in the city of Chicago alone signed up in the first five months of the program. He was instrumental in

getting the first charitable Illinois license plates issued to benefit the Organ/ Tissue Donor Registry. Today, these special plates are proudly designed in Bears blue and orange with a Walter Payton no. 34 football in the corner. Walter Payton's never-die-easy attitude in life and in dying is why more than five million Illinois residents are on the organ/tissue donor registry today, offering hope for a second chance at life to many thousands of men, women and children each year. It is an amazing, lasting legacy from an all-American hero—the greatest player and human being the game of football ever knew.

The Spirit of Walter Payton

Since his tragic death, numerous people have reported sensing Walter's vital, comforting presence at the Roundhouse, and the employees believe that Walter Payton's bright spirit keeps away the gloomy presences of the shadowmen. His presence is sensed most often in the Legends Museum dedicated to him at the Roundhouse. The EMF meters used during our ghost tours will occasionally act strangely in that room, even seeming to respond to our questions—one beep for yes, two for no. At our first Roundhouse tour on June 7, 2010, one female guest shot three photographs of our tour group in quick succession as we stood around Walter Payton's Super Bowl ring in its case. The first photo turned out fine, as did the third. But the second image was unlike any photograph any of us had ever seen. A low-resolution image was e-mailed to me a day later, so I can describe it here in detail. Brilliant white light radiates from the center of the photo, softening over the upper half of the image to a burnished gold hue, gleaming with shimmering, brushed metallic highlights. Not a single person showed up in the photograph—just vaguely human-shaped, hollowed outlines of electric white light standing around in the image looking like the aliens from *Close Encounters of the Third Kind* disembarking from the mother ship, several of whom even appearing to drift near the ceiling. If it was a flare from off the glass container around Walter's Super Bowl ring, it's the weirdest trick of light that I've ever seen. But I have no other logical, natural explanation for this bizarre yet strangely beautiful photograph.

In 2001, two years after Walter's death, his business partners Scott and Pam Ascher visited Wonewoce, Wisconsin, renowned for its impressive American Indian burial grounds and a spiritualist camp founded in 1911, dedicated to psychic communion with the dearly departed. Pam and her sister Rosalind wanted to attend a psychic fair being held at the camp that

weekend. Scott is quick to point out that he has no staunch belief in psychic abilities, but neither does he disbelieve either. He went with no expectation, with his only goal to enjoy an out-of-the-ordinary afternoon adventure. Scott got far more adventure into the unknown that Saturday than he ever believed possible.

The psychic fair at the spiritualist camp was a random setting of small cabins, out of which psychics of all kinds would conduct semiprivate sessions. There were astrologers, Tarot card fortunetellers, spirit guide psychics, crystal and rune readers and past life regression psychics, to name a few. Pam and her sister hurried off to keep their appointments with their chosen mystics. Every cabin was filled with customers—except one. One psychic stepped out of her cabin looking for her client who hadn't shown up for their appointment. Scott shrugged. "Eh, why not?" He paid her fee and went inside her cabin just to see what it was all about.

The psychic told him to pick a pen at random from the dozen or more that were strewn across the table. He was instructed to write his full name four times on the pad of paper before him. The psychic explained that occupying his mind on such a mundane task would relax his psychic defenses and open him up so she could readily pick up on any impressions around him. Scott was wondering if this psychic would pick up on the spirit of his father, Sherman "Poppy" Ascher, who had passed in 1993. When Scott finished the final signature, the psychic was frowning.

"I've never had this happen to me before," she mused. "Usually when people are signing their name I get many different impressions of spirits around them—family and friends who have passed yet whose love for you has never faded. But there's only one presence around you. And he's very insistent that he wants to talk to you. Tell me…" She scribbled briefly on her own yellow pad of paper and then turned it around and pushed it across the table for Scott to read. "Does this name mean anything to you?" On the pad of paper the psychic had written the name "Walter."

The tiny hairs on the back of Scott's neck and arms rose up and prickled with an eerie sensation. The odds that this woman had recognized his face or name as the deceased Walter Payton's business partner were slim to none. Was it a lucky guess? Scott played it cool and didn't let on that she had nailed her first read on him. "Okay," he said, "you've got my attention. Go on."

She paused, concentrating, and then said with a puzzled frown, "I'm getting something odd from him. Do you know a Louis?" No, Scott didn't know anyone named Louis. "He's very insistent," the psychic continued. "*Very* insistent. He's calling you Louis. He's telling you to meet him in St.

Louis…Louis. He wants me to tell it to you exactly like that, 'Meet me in St. Louis, Louis.' Does that mean anything to you?"

It did, and she now had Scott's full attention. The tiny hairs on Scott's neck and arms stood up straight again, and he nervously fidgeted with the pen. In 1995, Walter was working to expand his America's Bar restaurant and nightclub venture into St. Louis, Missouri. Scott was sharing offices with Walter at the time, and he kept hearing everyone talking about this project—how it was dragging on and on, with no real start date and no real plan. On a Friday afternoon, Scott walked into Walter's office with a business proposal. He told Walter that if he really wanted the St. Louis project to happen, all he had to do was give Scott the existing plans, such as they were, and he would redesign it, price the project up and give Walter a schedule to open. This package would include designing, building and training the staff. Walter gladly gave him the "go ahead," and on Monday Scott presented the finished proposal to Walter.

On Wednesday, Walter called Scott into his office. When Scott walked in, Walter greeted him with a big smile and sang the opening refrain from the classic old song, "Meet me in St. Louis, Louis." That was Walter's way of telling Scott that he had been hired! Walter and his investors had really liked Scott's proposal and wanted him to start work right away on the St. Louis project.

No one knew about the details of that moment of triumph for Scott. Scott had never even mentioned the singing incident to his wife of twenty-four years, who was also his business partner. It just never came up because it was never that important—until today. And now, here was this psychic, this total stranger, speaking the exact words that Walter sang to him in that special moment of his personal success: "Meet me in St. Louis, Louis." "Okay," Scott told the psychic, "you still have my attention. Go on."

The psychic appeared to be in some difficulty, her face showing signs of a struggle. Finally, she blew out her breath in exasperation and explained that she was trying to push this spirit away so that other spirits could have the chance to come forward, but he just…wouldn't…budge! She said that she had never experienced any spirit as stubborn or strong as this "Walter." She finally gave in and passed along his next insistent message to Scott.

"He wants you to call Eddie. Do you know an Eddie?" Trying not to show just how weirdly accurate this session was turning out to be, Scott told her, "Okay, you've *definitely* got my attention, go on." Later that week, Scott called Walter's older brother—Eddie Payton—and told him what had happened. Eddie said he wasn't at all surprised. In fact, if Walter *was* able to contact anyone, it made sense to him that it would be Scott.

Scott sat before the psychic, uneasily tapping the table with the pen. He knew that the psychic was getting all the names exactly right—Eddie, not Edward or Ed, and Walter, not Walt or Wally. But Walter wasn't done communicating with Scott yet. The psychic said that he wants to know if Scott celebrates a holiday in July at the Roundhouse? Not the Fourth of July, but another holiday in that same month. Scott couldn't think of what she was talking about. Another holiday in July? Scott couldn't think of what Walter was talking about. She tried to change the question or move onto another topic, but the spirit stubbornly kept coming back to it. "Celebrate in July! Celebrate in July!" It was only later that the answer finally dawned on Scott what Walter had been asking him to do—and every year since then on July 25 the Roundhouse celebrates Walter's birthday.

His time was up, and Scott knew that it was time to go. But Walter had one more surprise for him that day at the psychic fair. As Scott thanked the psychic, telling her that he was impressed, he was about to put down her pen when he happened to glance at it and froze in astonishment. Printed on the side of the pen were the words "Dancing Bear." Out of the dozen of pens on the desk, Scott had picked up the only one imprinted with one of Walter Payton's nicknames! Scott asked the psychic if he could take the pen with him and she said sure. He keeps it in his desk at the Roundhouse even to this day.

"SIGH!"

On June 7, 2010, I launched the Historic Roundhouse Ghost Tours, running every Monday night with Scott Asher's blessing (and Walter's, too, we think). It's the quietest evening of their week, so we enjoy darkened, lonely corridors, perfect for telling ghost stories, and the staff enjoys tips from all of those extra diners on an otherwise slow night. Any doubts that I once had that something supernatural is really going on in those old limestone walls were swept away after the first month. Life is full of coincidences, but we've experienced too many of them at the Roundhouse to be laid at the feet of pure chance.

The paranormal activity got off to a running start at our first-ever ghost tour there. Not only was there that strangely beautiful golden flare photograph taken by a tour guest in the Legends Museum, but three young women also recorded one of the finest EVPs I've ever heard up in the Stout Room. Have you ever played back a tape recorder and heard sounds that

you didn't hear at the time of the recording? Perhaps you heard footsteps, distant music, weeping or one or more voices speaking—but the room had been empty at the time? Paranormal scientists theorize that these ghostly sounds can be magnetically or electrically imprinted directly on the cassette tape or digital device, bypassing the microphone completely. Whatever the explanation, listening to recorded voices and sounds that were "audibly invisible" in real time is an unnerving sensation.

Guests on the tour are allowed to wander the haunted conference corridor and rooms after hearing the stories. Three ladies had stepped to the far side of the room by the fireplace to conduct an EVP session, asking questions aloud and pausing for several seconds after each one in hopes that a disembodied voice would answer them. After a few minutes of this, they played back the recording and listened for any unusual sound unheard by living ears. Suddenly, they ran back to where I was standing in the Stout Room, their eyes wide. "Listen to this! We caught an EVP!" I admit that I was skeptical. We had twenty people wandering that corridor, and none of us was being particularly quiet. But my jaw dropped when, on the playback, I heard a *loud*, distinctly male voice sighing in exasperation, as loudly as if it were directly into the microphone. You could easily imagine some ghost of a former roundhouse ironworker rolling his eyes at the seemingly "silly" questions they were asking, such as, "Is there a presence here with us now?" I had observed for myself that no man had been anywhere remotely near them, and the dividing curtains between the Stout and Lager Rooms, where they had been standing, were wide open, so no one could have hid behind them. How that loud, obviously masculine sigh got on there is a mystery. Every guest on the tour got a chance to hold that device to their ear to listen to this amazing EVP, and we always knew when they reached that part of the recording by the way their eyebrows would fly up in astonishment. The woman who owned the device promised that she'd e-mail me an mp3 of it, but unfortunately it never arrived. So if you're reading this, young lady with the recorder on our first ghost tour, please send it right away!

JUST IMAGINING THINGS…OR NOT

Like most serious paranormal investigators, I'm a hard-core skeptic. About 90 percent of all so-called paranormal events can be rationally explained by the natural laws of nature, whether they are physics or psychology. It's just that last 10 percent that defies all our scientific knowledge and reason and

keeps us searching for answers. But sometimes in the excitement of discovery, even skeptics can leap to thrilling conclusions—and keep on leaping until they run into a brick wall. In May 2010, my friend Bruce Cline from the Little Egypt Ghost Society in downstate Illinois (a region called Little Egypt by the locals) was visiting our neck of the woods when I proposed that we do an impromptu late-night ghost hunt of the Roundhouse. After getting the OK from the manager, Bruce and I, together with my good friend and business associate Lisa Condinho, settled down in the Stout Room to conduct an EVP session.

Bruce was eager to try out his newest piece of ghost investigation equipment called a PX, an experimental device that marks an evolution from two earlier versions, the Ovilus and the Puck. It was originally invented as an entertaining joke—a glorified Ouija board for "communicating with the dead"—by renowned paranormal equipment technician Bill Chappell of Digital Dowsing, LLC. The PX works by measuring changes in the electromagnetic fields around it. Each frequency level is calibrated to one of 2,047 words in a built-in dictionary, so every time there's a change in the energy field, it will speak aloud the different word keyed to that frequency. The theory is that an intelligent ghost can learn how to communicate verbally simply by adjusting the energy fields to the frequency that corresponds to the word(s) it wants to say. In addition to its dictionary, this newest model, the PX, is also able to phonetically pronounce words that are not in its stored database. It "speaks" in a mechanical, disjointed "voice" like the speech devices used by the disabled physicist Stephen Hawking and renowned film critic and throat cancer survivor Roger Ebert. But because the PX is a far, far cheaper version than theirs, it's difficult to make out the words it's saying, especially in the phonetics mode.

According to Bill Chappell, if you ask the PX a simple question, the odds of it giving a contextually correct, one-word reply from its dictionary database are 1 in 2,047. For example, if you ask, "Are you a man or woman?" and the device says, "candle," it's not a contextually logical answer. However, if it answers "man" or "boy," then it would be a sensible reply—and the odds are greatly against that. So when Bill began experimenting with his device, he was stunned to receive logical responses time and time again—even a few correct compound word responses—that went way beyond the odds. Getting back to our example, if you asked, "Are you a man or woman?" the odds for the device to reply "I'm a young boy" are astronomical. Yet occasionally Bill was getting such intelligent, multiple-word answers!

Still, Bill Chappell makes no miracle claims about his invention, and the words "For entertainment purposes only" are emblazoned on each device. The Ovilus, Puck and PX devices have stirred huge controversy among paranormal investigators, and tech geeks will happily argue for hours on whether it's a legitimate communications device or snake oil. Personally, I had strong doubts about Bruce's new toy, but as Bill himself states on his website at www.digitaldowsing.com, "Research is the only way we learn. Fail or succeed, it all brings us closer to the truth." Bill also says, "I'm just asking that people take a hard look at anything they are doing. Be objective and don't allow your emotions to mislead you when using one of the Digital Dowsing devices." Unfortunately, I soon learned that it's so easy for the PX device to lead even a skeptic's emotions skipping down the primrose path.

Bruce had his PX on during our monthly lecture presentation held in the Stout Room the night before, and it didn't make a peep all evening. But from the moment that Bruce, Lisa and I passed through the doorway into the haunted corridor that next night, the PX and the EMF meters wouldn't shut up! The lights in that hallway are motion-activated, so I maintained (and still do) a healthy skepticism about the EMF's behavior. But why would the meters spontaneously pulse from zero up to the highest red zone reading of five milliGauss and back down again in seconds and then repeat this strange activity at completely irregular intervals? And why did all three of our EMF meters bury the needle at precisely the same time but occasionally go off individually, even when standing side by side? This bizarre electrical behavior had all three of us scratching our heads.

After ten minutes of roaming the length of the corridor, puzzling over the weird EMF meter readings, Lisa and I finally settled down in the Stout Room, sitting at separate tables and facing different directions to view as much of the room as we could. Bruce went to the far end of the corridor and peeked through the windows of the heavy swinging doors that lead into the upstairs kitchen area. He observed that beyond the swinging doors against the interior wall was an open office door with a dim light, perhaps from a desk lamp, shining out its many glass panes. He turned back and walked past the Lager Room to join us in the Stout. As he approached, Lisa and I both heard a soft, rattling *bang* coming from down the hall behind Bruce. We agreed it sounded like a door with glass panes being shut. Bruce hadn't heard it—the PX in his hand was too noisy, chattering like mad.

For the next ninety minutes the PX jabbered at us nonstop; and if a mechanical voice could sound urgent and panicky, this did. The most frequently used words were the following: "video," "office" (or "officer";

we couldn't clearly distinguish), "light," "peril," "east" and "three doors down"—which was odd since the PX rarely says anything longer than single words. The PX also kept repeating a word that sounded like "mahr-i-dar," which we agreed sounded like an Irishman saying "murder." I told them that Irishmen did work on the CB&Q railroad, with many of them dying in the cholera epidemic of 1835 (see the chapter on the Root Street Cemetery). The roundhouse was built in 1856 after the epidemic, of course, but there were definitely plenty of Irish in Aurora working at the roundhouse.

It's a little unsettling to hear "Peril! Peril! Peril!" while sitting in a dark room, wondering if any of this had any meaning; was it all just gibberish, or should we be running for our lives? At one point, I asked aloud, "Which bay are we currently sitting in?" I figured that if this were the ghost of an 1860s-era Irish mechanic, he'd know which maintenance bay it was. There was a slight pause, and then the PX's mechanical voice droned, "fifteen." Instantly, Lisa and Bruce turned to look at me for confirmation. I shrugged and told them that I wasn't sure but thought we were in the thirtysomethings. After my question, "fifteen" was occasionally uttered among all the "perils" and "mahr-i-dars," when it hadn't been before. That was curious.

Eventually the motion-activated light in the corridor timed out, and we were plunged into darkness, with only the starlight from the exterior windows to see by. Now things might get really interesting! We sat there in the dark, straining all of our senses to the utmost for any hint of a shadowman, an inexplicable smell or a disembodied voice. The PX chattered on rapidly for about five more minutes and then started to slow, as did the EMF meters. The mechanical voice spoke less frequently as the time passed, and the PX gradually replaced its earlier words with new ones: "Emma," "George" and something that sounded like "LeDeau." Over the next twenty minutes, the PX and EMF meters slowed their activity, until they finally quieted down completely—leaving three ghost hunters sitting in the dark and staring at one another in bafflement.

Suddenly, we heard voices coming from the kitchen area, and the motion-activated lights blazed on as the swinging doors burst open. The bright light hurt our dark-adjusted eyeballs, and I yelped, "Ow!" That scared the bejesus out of the manager and the four burly Roundhouse employees with her! She didn't know that we were still there and thought that we had either gone home or into another area of the building since the hall light was off. But she was alarmed by more than just my uncanny wail coming from the dark, haunted corridor; she suspected that the Roundhouse had just been robbed!

She had been making her usual rounds to close up the building for the night and was in the upstairs kitchen area when she noticed that the glass-paned door to Roundhouse owner Scott Ascher's office was open and the desk lamp was on. Hours before, she had personally turned off the office light and shut the door. Cautiously, she went in and quickly noticed that Scott's computer monitor was gone from his desk. She couldn't remember if she had seen it there earlier. Just then, she heard an eerily mechanical voice coming from the shadowed corridor outside the second-floor conference rooms. Ghost or thief, she didn't care which—she wasn't about to face it alone! She raced to the first-floor kitchen and asked for volunteers to escort her. They all did, and together they hurried back up to the second floor and pushed through the swinging doors—and found three ghost hunters squinting at the bright light and wondering what was going on.

We were very disturbed to hear about Scott's missing computer monitor. We told the manager that we had been watching the corridor for shadowmen like hawks and that no one had passed in all the time we had been there. We also told her that we didn't steal anything, and thank heavens she believed us! Later on our way home, we were discussing the unusual PX and EMF readings we had that night, and I suddenly wondered if they could have had anything to do with the missing computer. Perhaps the computer monitor was the "video," and there was also the mysteriously closed "office" door and the office "light" that had been off but was mysteriously on later. The office itself was "three doors down" from the Stout Room where we were seated (past the two doors of the Lager conference room and the swinging kitchen doors to get to the office). And what if the Irish-sounding "mahr-i-dar" wasn't the PX phonetically pronouncing the word "murder," but a ghost warning us about the missing "monitor." The revelation took our breath away and replaced it with chilling goose bumps! Before our excitement could get the better of us, I reminded Bruce and Lisa that the manager wasn't certain if the monitor had been stolen or not. Perhaps Scott had taken it to do some work at home, and she couldn't remember if it had been there earlier when she first turned off the desk lamp and closed the door to his office.

Though it was nearly 2:00 a.m. on a Wednesday when I got home, I zipped out an e-mail to the manager, begging her to let me know what happened to the missing monitor just as soon as she could ask Scott. Sleep was impossible—I was too thrilled at what appeared to be an amazing paranormal encounter—so I thought about how some of the other words that the PX had urgently repeated could be connected to the possible theft.

"East": though my meager sense of direction gets mixed up in that round building, I figured we had been on the east side of the Roundhouse. So that could have been contextually logical. "Light": maybe the ghost was warning us that the thief saw the hallway light. Maybe a thief had already been in Scott's office to take the computer and suddenly saw the motion-activated light in the conference corridor turn on when Bruce, Lisa and I had entered from the other end? Panicked at the possibility of getting caught, he could have ducked under the desk and waited to see if we were going to go through the swinging doors or stay in the corridor. Perhaps he was freaking out to hear the oddly mechanical voice barking "office," "three doors down" and "light." Maybe he was just about to risk a dash out of the office when he saw Bruce peeking through the swinging door window. Scared, he hid again and waited until Bruce turned back and then shut the office door to discourage us from entering, which would perfectly explain the rattling door noise that Lisa and I had heard. Then, when the hallway lights eventually went off, it implied to him that we'd left the area—not realizing we were weird people who like to sit quietly in the pitch dark. He figured that the coast was clear and that the odd voice was just a machine left behind, so he sneaked out the office door and down the back kitchen stairs, stolen computer in his arms. "Peril": maybe it was a good thing we stayed put in the Stout Room!

I was trying so hard to not let my imagination run away with me—trying to stay coolly logical and scientific in my analysis—but this scenario was so plausible! Just then I recalled another word that the PX had said repeatedly and excitedly dug into my notes on the history of the roundhouse for the answer. I had assumed the bays had been originally numbered counting clockwise from off the main entrance, so the Stout conference room would have been bays thirty through thirty-two. But in my historical research notes, I found that the old bays had been numbered *counterclockwise* and had started from the first part of the building ever raised—the east side. So what is now the kitchen, back-of-the-house services (i.e., Scott's office) and banquet hall/upstairs conference rooms would have been maintenance bays seven through sixteen, with the Stout Room taking up the last three bays. We had been in the middle of the Stout Room when I asked of whatever entity was present, "Which bay are we in?" And the PX had replied "fifteen."

I didn't sleep a wink that entire night. I was so blown away by these amazing revelations. If I was right and the sequence of events was true—and if the computer monitor really had been stolen—this would be the paranormal discovery of the decade! And this revolutionary PX device really could

communicate with the spirits. Wow! For the next few days, I was nearly levitating in my excitement and agonizing that the manager hadn't replied to my e-mail yet.

But who or what were "Emma," "George" and "LeDeau" that the PX kept repeating slowly for the last twenty minutes before falling silent at the end of our session? Were they employees of the Roundhouse, either past or present? Were they the robbers? A possible answer hit me. Emmitt Smith and LaDainian Tomlinson were football running backs whom Walter Payton mentored and inspired and who eventually broke several of his NFL running records after Walter's death. Both men said they owed their success to Walter. And suddenly I knew…our PX speaker had been Walter Payton.

Dumbfounded with this stunning epiphany, all I could do for the next ten minutes was think, "Holy moly, holy moly, holy moly!" (Or words to that effect.) I immediately e-mailed Bruce and Lisa with my astounding theory and then dove deep into researching Walter Payton for any significant "George" in his life. My mind was reeling with the extraordinary possibilities. We had to document this. We had to get Bruce to print out a list of the words used by the PX that night. We had to get Jason, Grant and the rest of the TAPS team from the TV show *Ghost Hunters* out to Aurora right now!

I was convincing myself that "George" sounded a lot like "Jarrett" (Walter's son) when I received the manager's e-mail: "Dear Diane: I'm sorry for not responding to your e-mail earlier. Scott told me that nothing is missing. He switched the big monitor for a small one a while ago, which I didn't notice until that night, when I was freaking out thinking that someone was robbing us. Anyway, the open door and the desk light being on are still weird."

I was crestfallen. My entire fantastic paranormal scenario hung on the fact that the computer monitor had been stolen, but now that there had been no thief, my "Walter Payton's spirit was warning us about a robbery" theory popped like a soap bubble. The PX had only been reacting to some electrical frequencies that had been floating around for an hour or so—maybe someone had been vacuuming down in the ballroom. I felt pretty darn stupid at my phantom flight of fantasy and for letting my imagination go so wild in thinking that this glorified Ouija board was giving me irrefutable evidence for the existence of ghosts. I gave myself a stern lecture—don't jump to any false conclusions again!

And yet…the odds were 1 in 2,047 that the PX would correctly say "fifteen" when I asked the question, "Which bay are we in?" So I still find myself wondering.

Update: The paranormal activity at the Roundhouse has shot up just as I'm about to send this book manuscript to my editor, so I'm adding a few quick paragraphs while I can. This Monday's Roundhouse Ghost Tour confirmed it—that place is most definitely haunted. My ghost host Morgue the Mechanic (Curt Morley) reported the details to me. It occurred on Monday, July 26, when two handicapped guests and their escorts broke off from the rest of the tour to take the elevator up to the second-floor conference rooms while everyone else took the stairs. They rang for the elevator. The door opened, but it immediately closed right in their surprised faces. It opened and closed again and then again and again, at a mad pace, with the alarm bell ringing. The maintenance man hurried up, but he was stumped; he'd never seen the elevator do this before, and he had no idea what had gotten into it. It went on for about thirty minutes until the activity ceased as suddenly as it had started—the alarm stopped and the door slowly rolled open normally, as if inviting them all to step inside. No one did. Since they were unable to climb the stairs to finish the tour, Morgue of course offered to refund their tickets, but they refused, saying that with this possessed elevator they'd gotten more than their money's worth on this ghost tour already! (Note: the elevator has worked perfectly ever since.)

Not a few minutes after that, Curt—in full creepy character as Morgue the Mechanic—invited the tour guests to "step into the very heart of the paranormal activity within this building," threw open the doors to the Stout Room and waved them in. The first person to enter was an older gentleman, perhaps in his late sixties, who took a few steps into the room and froze in his tracks. He claimed that he saw in the far corner of the room a man wearing typical workman's clothing and a train engineer's cap. This workman looked over at the gentleman as he entered and then turned, walked two steps and vanished into the wall! Unfortunately, it all happened so quickly that this gentleman was the only person to see the apparition, but he was adamant about what he had seen. Several other smaller events occurred that same busy night: strange EMF meter readings, five self-illuminating orbs of light photographed outside of the elevator and a camera battery that was completely drained while in the Stout room but mysteriously became fully charged again when its owner took it out the conference room door. If this incredible paranormal activity keeps up during our Historic Roundhouse Ghost Tours, I'll be adding updates even as the book goes on the printing press!

DEVIL'S CAVE

Excerpted with the gracious permission of Curt Morley from his chilling audio CD Fox Valley Phantoms—*available for purchase at www.foxvalleyphantoms.com—because I couldn't have told it better myself.*

Devil's Cave is a small cavern located in the Red Oak Nature Preserve in Aurora, Illinois. It's a place of great natural beauty. It's also said to be haunted. For this is the place where Chief Waubonsie and a band of his Potawatomie warriors took a terrible vengeance on an evildoer.

There are many stories told about Waubonsie, the great Potawatomie war chief. Although the Potawatomie—along with all the other tribes in northern Illinois—sided with the British in the War of 1812, Waubonsie eventually realized that living in peace with the pioneers was in his people's best interests. He personally prevented the massacre of a large number of settlers when he hosted a celebration for the war parties from the Sauk and Fox tribes, who were intent on slaughtering the inhabitants of what is now Naperville. While the hostile Indians were occupied at his settlement, Waubonsie sent a message to the settlers, who then fled to Fort Dearborn. In 1826, Waubonsie was one of several chiefs who signed the Treaty of the Wabash, which helped normalize relations between the Native Americans and the settlers. During the celebration that followed, he was accidentally stabbed by one of his own braves. The man who was responsible fled. But Waubonsie allowed him to return to the tribe unharmed. When asked why he did not have the man killed, Waubonsie said, "A man who would run

away like a dog with his tail tucked between his legs for fear of death is not worth killing."

The chief's effort to live in harmony with the settlers was not popular with some members of his tribe. One brave continued to raid and steal from the pioneer settlements even after Waubonsie had forbidden it. He was cast out of the tribe. It was believed at the time that he went north to live with the Ojibway. As the year progressed, the wayward warrior was soon forgotten, and the Potawatomie turned their attention to tending crops and hunting.

It was in the autumn, the time of the harvest, that the evil came. Several members of the tribe turned up dead. Their bodies were found badly mutilated and scalped. An apparition was seen moving in the woods near the village. It was a glowing, man-like shape that would appear out of nowhere and, just as suddenly, disappear. Many felt that it was an evil spirit and that it was responsible for the brutal murders. Chief Waubonsie thought otherwise. He sent a group of his most skilled hunters into the woods to watch for this spirit. One night they heard the sound of someone approaching their position, and they hid in the underbrush. The spirit suddenly appeared before them. The concealed warriors were close enough to see that this supposed "evil spirit" was in reality nothing more than a cleverly disguised human being. He was wearing clothing that was covered with fox fire, the phosphorescent lichen that is found on dead trees. He was able to accomplish his mysterious appearances and disappearances by covering himself with a blanket.

The braves followed the man masquerading as a spirit to a small cave that bordered the Fox River. They sent a runner back to the village to tell of what they had seen. Waubonsie led a party of warriors back to the cave. They gathered wood and lit a roaring fire in the mouth of the cavern, then waited for the heat and smoke to drive their enemy out of his lair. Waubonsie and his braves were prepared to execute their quarry when he exited the cave, but the fire did their work for them. Screaming in pain, he flung himself into the river and died. When his body was recovered, the murderer was revealed to be the man who had been banished the previous spring. The cavern where the Evil One had hidden became known as Devil's Cave. It is said that the cave is haunted by the tortured soul of the killer and that on autumn nights his death scream can be heard as he relives his agony-filled final moments over and over again for all of eternity.

Author's note: In an Old Fox River *publication from 1995, journalist Violet Maurer Cooke wrote a feature article on Devil's Cave that went into hair-curling detail about the*

legendary "evil spirit" and other fascinating trivia and tales about the cave. It included the following details:

- *Al Capone's gang supposedly used it as a prime hiding spot for bootleg liquor.*
- *Famed folk singer Lee Murdock wrote his song "Kaneland" based on Devil's Cave.*
- *Author Charles Pierce Burton used Devil's Cave as a location for one of his "Bob's Hill" adventure books.*
- *Devil's Cave may be part of a much larger cave system said to be hidden under the Fox Valley Country Club, with passages possibly extending as far as the Burlington Northern Railroad tracks that parallel Route 25. A former director of the club, Ed Moses, was quoted as saying, "There's a spot near the tenth hole where fast-flowing rainwater from a drainage ditch just disappears into the ground. A real good stream of water will go into it." Rumor has it that this hidden cave system is as vast as Missouri's popular tourist site Meramec Cavern, which stretches 4.6 miles under the Ozarks.*
- *Devil's Cave extends about 30 feet, but rumor says that it once had two good-sized rooms and a 150-foot tunnel heading east and branching off under the river to the Mooseheart Ravine. Aurora legend has it that these were closed off during a cave-in that trapped two boys who had been exploring there. Their parents and neighbors frantically tried to dig them out and kept hearing their cries: "Help, the roof's falling down and we're stuck in the rocks!...We can't move!...Hurry, please hurry!" The rescuers kept digging, but to their dismay they could hear the cries of the two boys growing fainter and fainter. Then...deathly silence. Devil's Cave had swallowed two young lives. It's said that their skeletons are still entombed deep in the lost, secret chambers and that their haunting, despairing pleas still echo down in the dark throat of Devil's Cave.*

MURDER IN ST. NICHOLAS CEMETERY

On the night of February 16, 1914, Tressa Hollander, the twenty-year-old daughter of German immigrants, attended a social gathering in downtown Aurora with her father. Tressa went home early, while her father remained behind to play cards. It was a decision that he later never forgave himself for. Tressa took the streetcar and hopped off at her stop just two blocks from her house on Aurora's east side. She started walking down the snowy sidewalk…but she never made it home.

Her father got back very late from the card game. His wife had already gone up to bed as, he assumed, had Tressa. It wasn't until the next morning that the alarmed parents discovered that she had not come home, and they frantically searched the route she would have taken from the streetcar stop. On the sidewalk outside the St. Nicholas Cemetery on Ohio Street, her parents found a trail of blood leading inside the graveyard. Following the track of gore with mounting fear, their worst nightmare came true when they found her brutally beaten body just inside the cemetery gates.

The horror of that moment was described by Mr. Hollander to the *Beacon-News* reporter. "She was lying on her back in the snow. It was terrible. Her eyes were open and she seemed to be looking at me. Her hands were cl[e]nched and frozen. I took hold of her and begged her to speak but she was still." It was later determined that Tressa Hollander had been repeatedly clubbed with either a pipe or pipe wrench. The sheer savagery of the damage indicated that the murderer had been in the grip of extreme

Tressa Hollander's brutally beaten body was found by her horrified parents just inside the St. Nicholas Cemetery gate. *Author's collection.*

passion or madness—and suspicion immediately fell on Tressa's former suitor, Anthony Petras.

Anthony was obsessed with the young woman, and on several occasions he swore to kill her if she ever married another man. When she broke off her relationship with him, he threatened to dynamite her house. Tressa's parents claimed that he was so insanely in love with their daughter that he married someone else just to spite her. Anthony Petras was twice brought to trial on murder charges but was acquitted both times because what meager evidence they had against him was largely circumstantial. She was buried at St. Nicholas Cemetery, but to this day, Tressa Hollander's vicious murder remains an unsolved mystery.

This is undoubtedly why Tressa's bloodstained ghost is said to walk the grounds of St. Nicholas Cemetery. Aurora legend whispers that her restless, vengeful spirit will haunt the place of her death until her killer is brought to justice. But who *did* murder Tressa Hollander? Was it Anthony Petras? Or was it someone with an even darker passion than Anthony's obsessive lust?

It is said that the ghost of the murdered young woman, awash with blood, will walk in the cemetery until her killer is found. *Author's collection.*

On November 20 of that same year, 1914, another young woman, Jennie Miller, was found cruelly beaten to death. Then lovely Emma Peterson's horribly battered body was discovered on February 25, 1915. In all cases, the murder weapon was determined to be a pipe or pipe wrench, and in all cases their murderer was never found.

SUICIDE SKYSCRAPER

Dominating the Aurora skyline is the Leland Tower Hotel at 7 South Stolp Avenue on Stolp Island. In its heyday, it was the tallest skyscraper in Illinois outside of Chicago, and it is still the tallest in Aurora. Construction began in 1926, and when it opened on February 7, 1928, this steel-framed structure soared twenty-two stories high above the Fox River. Given the double attraction of its lofty height and the river below, the Leland has the dubious distinction for being an irresistible magnet for every suicidally inclined jumper in four counties. Ever since it opened as the Leland Tower Hotel, on up until today, the west side of the twenty-first floor was the preferred leaping-off point for suicides. This was especially true in the year after the hotel opened, when the stock market crashed on "Black Tuesday," October 29, 1929, marking the start of the Great Depression. Not surprisingly, this particular area of the building is said to be extraordinarily haunted, with ghostly replays of despairing souls reenacting their final moments, whether they had jumped...or had been pushed.

The Leland was designed in the Italian Romanesque Revival style, covered in brick and terra cotta. On the top floor was the swank Sky Room, a first-class dinner and dancing hot spot that attracted celebrities and wealthy socialites even all the way from Chicago. It was the place to see and the place to be seen, and some of the famous and infamous personages known to have admired the spectacular views included John Dillinger, Al Capone (allegedly a regular), Philip K. Wrigley, Gene Autry and the notorious fan dancer Sally Rand, among many others. After the party, most guests would

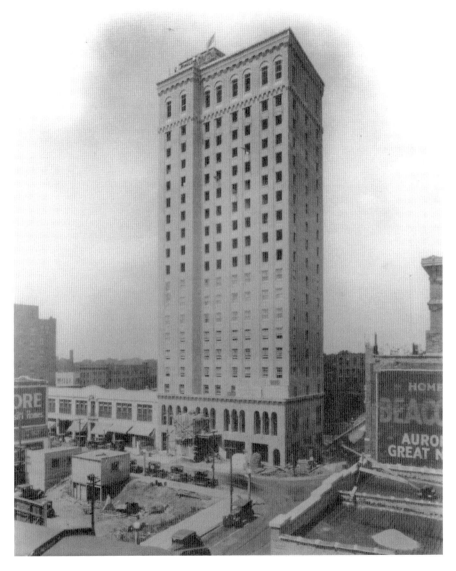

Constructing the finishing touches on the Leland Tower Hotel in 1926. *Courtesy Aurora Historical Society.*

spend the night at the hotel, if only for the novelty of calling a friend from the telephone in their room—a modern luxury unheard of for even downtown hotels. Also known as the Top Floor, the Sky Room was renamed the Sky Club after World War II.

The Sky Room was a second home to Bluebird Records, a Chicago-based blues and jazz label subsidiary of RCA Victor Records that boasted a monopoly on the finest blues artists in Chicago. In 1937 and '38, it held recording sessions after hours up at the top of the tower for such blues musicians as Big Bill Broonzy and Tampa Red. The most legendary blues artist to play there was John Lee "Sonny Boy" Williamson, who made his first recording of his famous "Good Morning, School Girl" on the Sky Room stage in May 1937. Sonny Boy did vocals and his blazing blues harmonica, with Big Joe Williams and Robert Lee McCoy (aka Robert Nighthawk) on guitars. The song, also called "Good Morning Little School Girl," became a classic blues standard that has since been covered countless times by such artists as Eric Clapton and the Yardbirds, the Grateful Dead, Motörhead, Widespread Panic, Rod Stewart and Huey Lewis and the News, among many others.

Now called the Fox Island Apartments, other paranormal phenomena said to occur at the former Leland Tower Hotel includes a disturbing moaning sound coming from the elevator shaft and horrible smells of something rotting rising from the river—presumably a different rotting smell than what would normally be found at any river. A few of the current residents say that they've seen the ghosts; one man even claimed to have seen "a ghoulish skeleton walking around." Lights are said to flicker, and radios turn off and on for no earthly reason. One resident claims to sense a very intense aura in the early morning hours, as well as mysterious orbs and gateways in her apartment. However, still more residents say that they haven't noticed a single paranormal thing in all the time they've lived there and love the stunning views and its prime central location in the lively heart of downtown Aurora.

THE PARAMOUNT PALACE

The year is 1931. The world's tallest building, the Empire State Building, opens in New York City. Unemployment hits 16.3 percent as effects of the 1929 stock market crash worsens. Mobster Al Capone is indicted on five thousand counts of prohibition and perjury and is later sentenced to eleven years for tax evasion. William Shatner and Leonard Nimoy are born on March 22 and 26 and become Captain Kirk and Spock thirty-five years later. A small community in Nevada decides to legalize gambling, and Las Vegas thrives in the Depression. Dick Tracy and Donald Duck become comic favorites. A fizzing tonic called Alka-Seltzer first goes on sale. And on September 3, *Secrets of a Secretary*, a movie made with the new "talking picture" technology starring Claudette Colbert, was playing at the newly opened Paramount Theatre movie palace on 23 East Galena Boulevard. Originally commissioned by theater mogul J.J. Rubens, he sold it even before its construction to the Paramount Famous Lasky Corporation. Designed in a unique Venetian style with an Art Deco influence by architects George and C.W. Rapp at a cost of $1 million, the Paramount became the gold standard for a wave of sumptuously ornate movie palaces that Paramount Pictures built across the nation.

Describing "The Show Place of the Fox River Valley," as it was proclaimed on its opening, requires excessively florid poetic prose, so please brace yourself before reading this next paragraph. The Paramount's exterior boasts intricately detailed terra-cotta work in lavish color that seems to glow in the dazzling radiance of the electric Paramount sign

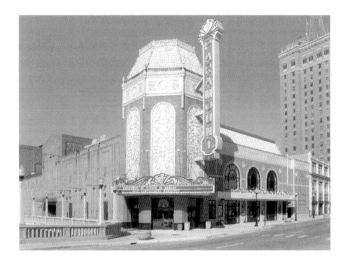

The Paramount Theatre is one of America's last surviving "talking picture" movie palaces from the 1930s. *Courtesy Paramount Arts Centre.*

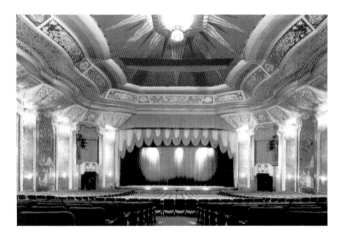

After a $1.5 million restoration in 1976–78, the sumptuous grandeur of its auditorium once again made the Paramount the brightest jewel in Aurora's crown. *Courtesy Paramount Arts Centre.*

and theater canopy. All of the elegant Art Deco splendor in the lobby simply prepares visitors for their first sight of the auditorium. The split doors open grandly, and the visitor steps into a paradise vision of gorgeous opulence beyond the dreams of the Depression-era masses. Designed to evoke gasps of stunned wonder, the auditorium sweeps magnificently down in a sea of shining gold to the velvet stage curtain and lushly draped proscenium. Crimson silk wallpaper tapestries line the towering walls from floor to ceiling, embellished with idyllic scenes of European travelers in the exotic Far East. Each mural is interspersed with fluted panels of metallic red gold spilling like waterfalls of fire in the footlights. Overhead, the ornamental sunken caisson depicts a celestial blue sky, with rays bursting

from the enormous glittering crystal chandelier like starlight. Translation: the Paramount is really, *really* pretty.

The Paramount movie palace was an architectural showpiece, the jewel in Aurora's crown—and a serious competitor to downtown Chicago's entertainment industry. The Paramount was designed specifically to cash in on the new "talking pictures" movie craze that took off with *The Jazz Singer* in 1927. But what really made Aurora a serious rival to Chicago's prominence was that the Paramount was the first air-conditioned building outside of Chicago in the entire state. No longer did people flock to the city on the lake to marvel at the sensation of frosty cold air in the heat of midsummer; they came to Aurora in droves. With its array of theaters, fairs, circuses and parks, Aurora flourished as the entertainment center of Illinois. While most of America endured the misery and hunger of the Great Depression, Aurora was a major hub of wealth, industry, cosmopolitan glamour and big city crime.

For the next forty years, the Paramount Theatre entertained audiences with a variety of world-class entertainment, from "talking pictures" and vaudeville performances to concerts and circus acts. Groucho Marx was the first live act to appear on the Paramount's stage, and the parade of stars that followed him reads like a who's who of comedy, including Jack Benny, Will Rogers, George Burns and the Three Stooges, to name a few. The greatest names in acting and music from Hollywood's golden age appeared at the Paramount, either on the silver screen or live—and sometimes both.

But by the 1970s, the Paramount had declined into decay and neglect. The era of the magnificent movie palaces had passed, and out of all the fabulous buildings erected by Paramount Pictures across the nation, only the original Paramount in Aurora was still operating, if barely. Gleaming new multi-screen mall theaters took over, and few people chose to go to the second- and third-run movies that the Paramount played in the crumbling, water-stained wreckage of the once-glorious auditorium. But in the patriotic fever of the 1976 American bicentennial, the Aurora Civic Center Authority bought the Paramount and closed it to prepare for a massive, $1.5 million restoration. It took two grueling years and herculean fundraising efforts, but at last the beautifully restored Paramount Arts Theatre was reopened on April 29, 1978, offering the best theatrical and live entertainment in the suburbs.

An elegant twelve-thousand-square-foot lobby christened the "Grand Gallery" was added in 2006. Featuring a state-of-the-art box office, a gift shop, a snack bar and an art gallery, the classically handsome interior is a popular setting for business functions, weddings and other special events. In 2009,

the Paramount played a part in the blockbuster movie *Public Enemies* starring Johnny Depp as John Dillinger. In a scene that likely replayed history, the notorious gangster and frequent visitor to Aurora was seated in the audience watching a newsreel about himself. Today, the Paramount Arts Theatre is enjoying a renaissance of its heyday, once again attracting and entertaining thousands of theatergoers with top-name performers, concerts, comedians and the best of Broadway amid a jeweled setting of breathtaking splendor.

THE SHOW MUST GO ON

"Nobody's more superstitious than showbiz people," R.T. Lorenz told me on a winter afternoon in February 2010. The Paramount's house electrician pointed up at the stage, where the traditional solitary light burned. "Frank Sinatra wouldn't enter this theater until his handlers would assure him that the ghost light was on. I never knew why, but that's a true story." The Paramount staff had graciously granted me an interview to relate a few of the stranger stories that have taken place at the eighty-year-old movie palace. There are shadows of long-dead moviegoers from the 1930s and '40s sitting in the plush seats, distant notes of an old vaudeville song being sung in a dark dressing room—the usual ghosts one would expect in a theater. It's some kind of a paranormal principle that every old theater is required to have its share of ghosts, and the Paramount is certainly no exception. The only difference with the Paramount is that the "real" ghosts are part of the family—three generations worth of loyal Paramount backstage employees who make sure that the show goes on.

The current staff knows exactly who's haunting the Paramount—Mickey Foster and Jerry Close. Mickey was the projectionist back when the palace was still a movie theater and later became the house technical director, working primarily backstage. Jerry was the head audio engineer, working the sound and operating the spotlight up in the old projection booth high in the back of the auditorium. Together they were the very best of friends for nearly their entire lives—and apparently in their afterlives too, because the two most paranormally active spots in the theater are the backstage and the projection booth, according to the current house technical director, LouAn Kates, who is also Mickey's daughter.

Jerry Close's unexpected death in 1982 from complications during heart surgery was a terrible shock for everyone at the Paramount. He was such a vital, fundamental part of their close-knit stage family that it seemed

impossible that he was gone. Jerry appears to not believe it either, and it's generally assumed that he's still up in the projection booth, in which he had spent more time than his own home. People in the booth often complain that they smell one of Jerry's freshly lit cigarettes, though smoking is no longer allowed anywhere in the theater. But even more common is the experience of feeling a cool breeze drift by in the usually airless projection booth, and suddenly they distinctly sense the presence of their former co-worker, Jerry, standing there behind them, critically watching their every move in case they miss a sound cue. No one has missed their cues yet while Jerry's ghost is standing by, so no one knows what he'd do—and no one wants to find out!

Mickey Foster hasn't left the building yet, either. Lights mysteriously flick on and off backstage, objects vanish from dressing rooms and prop tables, unseen hands move curtains and a man's deep voice has barked orders from empty air. The members of the cleaning staff have reported seeing the shadowy outline of a man crossing the stage long after everyone has gone home. Others are bewildered to clearly hear footsteps briskly pacing back and forth across the empty stage yet see no one illuminated in the ghost light. LouAn just smiles to hear these claims, for she too sometimes hears a familiar footstep or glimpses a dearly remembered figure pacing in the backstage shadows. Her father was a compulsive pacer onstage, and she's glad to know that Mickey is still there, keeping a sharp watch over the theater he loved.

'TWAS THE NIGHT BEFORE THE CHRISTMAS SHOW...

Mickey keeps watch over the people he loved, too. One night, R.T. was working late to put up the Christmas decorations that have become as much a cherished tradition at the Paramount as the Christmas show. It was about 10:00 p.m., and R.T. was alone in the building, standing high up on a ladder in the old lobby, getting the wiring right on the carolers to make them move their arms and sing. He was exhausted, having worked for almost forty-eight hours straight without a rest. But he was absolutely determined to have all the favorite, well-loved decorations up in time to not disappoint the families who come each year to the Paramount for Christmas.

Suddenly, a very familiar voice kindly spoke from the second-floor landing at the top of the stairs not thirty feet from where he was standing; "It's time to go home, son." R.T. knew that voice better than his own. He had heard that voice every day for most of his life, speaking in every kind of mood and at every level of volume, from an urgent whisper backstage to a bellowed

command from the back of the auditorium. It was the voice of the man who used to call him son, since he was so much like a father to R.T. There was simply no mistaking Mickey Foster's distinctive voice, clearly calling to him in that still, silent lobby—though he had been dead for some years now. R.T. couldn't swear to it, but out of the corner of his eye he thought he glimpsed his former boss and mentor standing on the landing over the lobby, his rough, weathered hands resting on the Art Deco railing. But when R.T. shifted on the ladder to look directly there, the landing was empty. Chills ran down his spine and every hair stood on end, but it wasn't fear that made him pack up and leave. After all, this was his dear friend Mickey, and R.T. had always obeyed his boss in life, so he sure wasn't about to disobey him now.

There was also the time when the Paramount ghosts became irked at one of the visiting lighting technicians prepping the lights for the Kenny Rogers Christmas Show. The Grand Gallery had recently opened, and one of the tour techies had made several disparaging remarks about the beautiful new addition. Ignoring the scowls from the house technicians, she went to use the ladies restroom off the Gallery. Suddenly, she came running out shrieking in terror—the restroom was haunted, and the ghosts were going crazy! LouAn and R.T. dashed into the restroom in time to see the stall doors swinging angrily and the toilet seats flapping up and down, the toilets flushing repeatedly without pausing—but only along one row of bathroom stalls and nowhere else. The area-specific chaos stopped as abruptly and mysteriously as it had begun, leaving R.T. and LouAn gaping in astonishment—then they burst into whoops of laughter as they realized that Mickey and Jerry had taught that lighting technician a lesson in manners.

The spirit of the Paramount's former tech director still keeps an eye on things from this spot on the lobby's second-floor landing. *Author's collection.*

Like all theaters, the Paramount in Aurora is haunted. But unlike other theaters, these spirits are cherished members of this special stage family and provide a kind of reassuring knowledge to LouAn and R.T. that the show will always go on at the Paramount. "People ask me if we're infested with ghosts," says R.T. "And I tell them, 'No…we're protected by them.'"

DON'T GO INTO THE PIT

Mickey Foster and Jerry Close may be the primary ghosts haunting the grand old movie palace, but sometimes visitors bring their own guardian spirits with them. R.T. recalled the time he took a recently arrived traveling show's crew on a tour of the backstage area to familiarize them with the maze of damp corridors and cubbyhole rooms below the stage. The visitors were surprised to see that these areas are actually below the level of the Fox River, and in some rooms you can look out the windows to see the river flowing along *above* the windowpanes when the river's high. Several times in the Paramount's history the river has flooded the lower levels, most recently in 1997 when the waters rose six feet into the orchestra pit. Though the building suffered water damage, it was a miracle that the most expensive lighting and electrical equipment were kept safe from the water.

R.T. was escorting the tour company under the stage. He ducked low to enter the tiny, narrow door that led to the orchestra pit, and the crew followed right after him—except for the wardrobe technician. He had abruptly stopped at the pit door, causing a momentary pileup of people coming through the dark entryway behind him. His face drained of all color, and he stumbled back in his haste to get away. The wardrobe technician pushed past the crowd of his co-workers and didn't stop walking until he was back out into the main room under the stage. No amount of persuasion could convince him to pass through that tiny door into the orchestra pit. Much later, he confessed that he had felt an unseen presence barring his way, warning him of extreme danger, and he somehow knew, beyond any possible doubt, that if he entered into that orchestra pit he wouldn't ever come back out. So strong was the wardrobe technician's premonition that for the entire run of the show he always took the long route to reach the other side of the stage at every performance, no matter how many times he had to madly race up, over and around the back of the stage in time to make the costume changes. To him, anything was better than passing near that pit door by the shorter, faster and much scarier route.

THE MCARTHUR/ KENNEDY HOUSE

One night as we sat with friends at a restaurant after attending a terrific production of Chicago in Geneva, the conversation turned to ghosts. I mentioned that I was researching ghost stories of Aurora, and my friend Aimee Kennedy promptly piped up and said, "My house in Aurora is haunted." It turns out that Aimee lives in one of Aurora's oldest original homes, built in the 1840s. It's even listed on the City of Aurora Historic Preservation website at www.aurora-il.org. Enough weird things have happened there since she moved in that she invited two paranormal investigative groups to stay overnight and investigate. I wrote notes about her experiences as best I could on a napkin, and then, when that was filled up, the back of the bar receipt. Fortunately, Aimee offered to e-mail me her story. Here is her actual e-mail, with only very minor edits by myself. Thanks, Aimee!

Diane,
I hope the account I have to share is worth mentioning in your collection. I found my home in April 2008 on www.historicproperties.com, and before then never would have believed that I could fall in love with a small brown house. In an effort to preserve the Greek Revival home built by Scottish immigrant Alexander McArthur in the 1840s, the Aurora Historic Preservation Commission moved it to its current location after a company bought the original site on South River Street in order to build condos there. The city recruited civic-minded volunteers to help restore it to an adorable and livable appearance to what it might have looked like after Alexander's son John modified the home during the time of the Civil War, when it is recorded to have had 14 people residing in it. No wonder they needed an

attic! The home is also noted by the City of Aurora to have been a host to [the famous detective] Allan Pinkerton and his wife when they were stranded on the prairie not long after their arrival from Scotland.

The McArthurs are listed on the census from 1850 to 1880. The 1890 census was lost. Fremont Taylor, a jeweler, and his family are listed as the next owners of the home starting in 1900. His wife Elizabeth died around 1906 and Fremont himself succumbed to an early death around 1916. Their children, Armenia and Charles, survived into adulthood. In 1920 George Phelps, a barber, and his wife and two daughters took up residence. His daughters both died before they reached their twenties while the Phelps resided in the home. There is no public record yet for who lived there after that, though it is recorded that the home was turned into a restaurant and then a bus depot, and then again refigured into a private residence.

My experiences are not dramatic or overly unusual. I have been exposed to supernatural occurrences since first grade when I lived in an Edwardian home in southeast Kansas starting at the age of six. I would nightly hear the descent of footsteps on the winding staircase and scraping of chairs in the dining room when I knew full certain that neither my parents nor my sister had risen from their beds. It was something I came to expect, something I knew was happening on another level that I could not explain but felt comfortable with because there was no malice intended.

I knew from the moment I saw the photos on historicproperties.com that this was the home I was meant to live in. My bid was the one the city chose, and I signed the mortgage paperwork and peacefully slept on the floor of the master bedroom the very day I signed.

The end of the first summer I lived here I experienced an event like I had never known before. I walked in from the kitchen door straight into the hallway, and from the left I saw a strange vision that caused my consciousness to alter sideways, and I almost tripped and fell. It was a small, towhead blond figure with massive upper arms, reminiscent of Popeye. I blinked and it took all my determination to stand up straight and remember the situation. It was not scary, so I logged it away to help me remember what I could look forward to experiencing in the future.

I invited the DuPage Researchers and Investigators of the Paranormal team (DRIP) to investigate in January 2010, and then Kindred Spirits in May 2010. The other story I have occurred on the day after DRIP took their readings. I was in my bedroom getting dressed, and my cat Maddie was tucked up in the very center of my bed. I noticed she was looking at me so I asked why—she is a very vocal cat so when I talk to her she always "talks"

back. She said nothing, just kept staring. So then I noticed she was actually looking behind me, over my left shoulder toward the corner. Which is, of course, the farthest corner of the room.

Knowing that my cat saw something behind me, my first instinct was to believe it was a bug, even though it was the first week in January. I turned and looked. No bugs. Maddie did not give her bug meow anyway, so I turned back and looked at her again. Her eyes briefly caught mine but then stayed trained on the spot behind me over my left shoulder. This unnerved me a little. Out loud I said, "I'm getting dressed and I would appreciate anyone else in this room to leave now and respect my privacy."

There are three doorways in the master bedroom: the one leading into the parlor, the one into the hallway, and one that used to lead into the next room before it was remodeled into the bathroom, so now it is the closet door. When the house was built in the 1840s, the bedroom, hallway and bathroom were all just one single room. These details are important, I believe, due to what happened next.

The door closest to me then, the closet door, was inches away from my shoulder. I watched my cat's eyes wander toward the closet door at a steady pace. Then she turned her head and her eyes kept steadily following—right past the door leading into the hallway. She then physically turned her body and watched whatever I had commanded to leave go through the door leading into the parlor—the opposite corner from where she began watching it. When it was out of her sight she got bored, raised one dainty leg, and began to wash her thigh.

So why do I think the history of the rooms and doorways are important? Because it seems that whoever was watching me dress and in the process entertaining my cat, did not recognize the closet or hallways doors to be portals from the room, as if they did not exist in that plane. It seems that I was listened to and my wishes were obeyed, and they left through the only door they "knew." It is not certain when the one room was closed off into two rooms with the narrow hallway; it could be as early as the Civil War when Alexander McArthur's son John added the attic and back rooms, when there were 14 people living in the house. But it could also have been any time after that. Whoever (or whatever) it was, my cat has not "seen" them since.

MYSTERIES OF ROOT STREET CEMETERY

No one knows how many bodies still lie beneath the grass at Aurora's oldest public graveyard. No one knows where they lie or even who many of them were in life. Those few who are remembered include Aurora's earliest pioneers, prominent founding citizens and soldiers fallen from the Civil War, the War of 1812 and the Spanish-American War—though exactly where their final resting places may be located in this open field bounded by Root, Flagg, Benton and LaSalle Streets is unknown. What is undisputed about Root Street Cemetery is the sad, century-and-a-half-old history of vandalism, carelessness and indignity endured by the residents of this hallowed ground. If disturbed graves can cause restless ghosts to rise up and haunt the living, then Root Street Cemetery seethes with unsettled spirits.

The first mystery is that of the cemetery's origins. Assertions in a 1907 *Beacon-News* article and later documents are not borne out by research. Here are the facts as John Jaros, executive director of the Aurora Historical Society, has been able to piece together from a puzzle of several conflicting and cryptic sources. On September 1, 1847, Dr. Anson and Mary Root deeded twenty acres of land on the east side of the Fox River to Charles Bates. Anson Root was a prominent Elgin physician who owned substantial property in Aurora. In June 1848, records show that it was either Dr. Root or Charles Bates who donated about three-quarters of an acre on the north side of the property to the Village of Aurora trustees "for a public burying ground."

The sad ruins of Root Street Cemetery are shown here in 1930. Neighborhood boys used the vandalized gravestones as bases for ballgames. *Courtesy Aurora Historical Society.*

The timing proved fortunate. In August 1949, a true horror came to Aurora as the terrible Asiatic cholera epidemic swept through America and Europe that year. In Paris, France, cholera claimed 14,127 lives, the worst outbreak in the city's history. The disease ravaged London and Liverpool and nearly drove the people of Ireland, already decimated by the potato famine, to the brink of extinction. It was primarily the Irish and French immigrants who unknowingly carried the deadly virus across the Atlantic, and thousands died in the major port cities of America's East Coast. Not even the rich and powerful were safe from this plague, as proven when U.S. president James K. Polk succumbed. Wherever the immigrants settled in America, death soon followed. They traveled to Chicago, St. Louis and New Orleans seeking employment but unknowingly carrying cholera that would infect the very bloodstream of America's heartland, the Mississippi River system. Gold rush fever sent thousands of adventurers along the California, Mormon and Oregon Trails, only to die from the cholera fever along the way.

Lured to Aurora, Illinois, by the plentiful jobs offered by the numerous manufacturing shops that sprang up in this vibrant, progressive town on the Fox, the immigrants brought the cholera here, too. Aurora's first victim died on or about August 7, and by August 30, the *Beacon-News* listed forty-five cholera deaths. The total death count in Aurora was said to top sixty

victims, perhaps half of them from Aurora's French Canadian immigrant population. The grieving Charles and Melinda Bates buried their youngest son, George, on their land—one of the first victims of the dreadful disease. His gravestone is one of the last few still standing in Root Cemetery today. Then, in April 1850, Charles and Melinda Bates sold the remainder of the property south of the public burying ground for seventy-five dollars to the president and trustees of the Town of Aurora "for the use and purposes of a burying ground." This deed had a stipulation that a certain portion should be set aside as a "potter's field" for the burial of strangers and those unable to afford burial plots. There may also have been a provision to the land deed that if the cemetery was ever abandoned and the bodies removed, the land would revert back to his heirs (or, at least, that's what the heirs tried to prove a century later, without success). But John Jaros has confirmed that both deeds apparently conveyed the lands for use as a cemetery in perpetuity.

The Missing Mass Grave

Perhaps the most persistent of Root Cemetery's mysteries is that of the missing mass grave. Aurora's transmitted oral history states that more than one hundred Irishmen are buried together in a mass grave believed to be located somewhere in the southeast corner of Root Cemetery. Though it's commonly held that they perished in the cholera epidemic of 1849, not a word was mentioned about them in the list of deaths in the August 30 *Beacon-News*. There were certainly Irish in Aurora at the time, working on building the Aurora Branch Railroad up until October 1850. The Irish were widely reviled across the United States, even though they likely suffered the highest mortality from the disease of any other immigrant ethnicity. But no Irish deaths in Aurora were reported at all. Was prejudice against anyone of Irish descent so deeply ingrained that the newspaper wouldn't even report their deaths? With Aurora's proud tradition of social progression, as well as the gruesomely sensational story it would have made, such a scenario is highly unlikely. So where did this ghastly story come from? Is it even true?

The answer to the mystery might quite literally lie at Benton and LaSalle Streets. This was the location of the original 1835 village cemetery. This land was absorbed into Root Street Cemetery in the 1850s when the known graves were exhumed and reburied at the newer location. By the 1860s, houses had been built over much of that early cemetery land.

Also in 1835, cholera swept through the Midwest, and it's very possible that these hundred Irishmen had died from this earlier, less well-recorded epidemic. These men probably came to Aurora to find their fortune but perished too far across the sea from their loved ones to claim their bodies. So they were all laid to rest in an unmarked mass burial lot in the pauper's section of this small village cemetery; which may have been hastily opened at Benton and LaSalle just for this purpose. A large, rectangular indentation in the earth had been the only remembered evidence of the exact whereabouts of this mass grave, but over the years weather and neglect removed even that last trace. With no markers or surviving records, there's nothing left to verify that this mass grave or those men had ever even existed—nothing except for old-timers' tales of a lost grave for one hundred dead men.

THE RESURRECTIONIST INDUSTRY IN AURORA

On the afternoon of March 24, 1871, some boys were fishing along the shore of the Fox River near Montgomery. In the mud and reeds over the riverbank they discovered what appeared to be a woman's foot sticking out of the water. The police were summoned, and soon the mutilated body of a young girl was pulled from the river. The *Aurora Beacon* reported that her face looked "as natural as it did in life" and that "a tranquil expression was on her countenance." Most disturbing was that she had a long, vertical cut down the length of her torso, with another deep cut just below her waist. Though the water had done much to decompose the body, it could still be determined that these distinctive cuts hadn't been made by a sharp rock or branch in the river—they were the clean, straight slices of a sharp surgical knife. The body was kept on ice for a week before it was finally identified as nineteen-year-old Eliza or Elizabeth Ann Bates—she had been buried in Spring Lake Cemetery one week *before* her freshly carved corpse was found in the mud. Records show that she had actually died on February 4, but she couldn't be buried until a few weeks later—probably because the winter earth was frozen. Her actual cause of death had been arsenic poisoning, a popular and occasionally lethal ingredient in many women's cosmetics at that time. Elizabeth's vanity had quite literally killed her, as it had many women who knowingly chose to risk their lives for the perception of porcelain-skinned beauty that this deadly substance brought them. But Elizabeth most certainly had not been buried with two deep, telltale knife slashes in her body. The postmortem cuts revealed exactly what had happened to this tragic girl's corpse to put her in the river, and the Aurora police knew exactly who to talk to about this shocking crime: Dr. Frederick L. Pond.

During the nineteenth century, the demand for cadavers by doctors and medical colleges to study human anatomy and surgery firsthand resulted in the lucrative new "resurrection" industry. These resurrection men would read the obituaries to find out who had recently died in the area. Then, in the dead of night, they would sneak into the graveyard and secretly dig up the body, while the grave earth was still fresh, and then sell the corpse to their customers: surgeons and medical schools. With its unusually high number of cemeteries, Aurora offered a bountiful and varied crop for the body snatchers to harvest; and with the numerous medical colleges in Chicago and the opening of the Medical Department of the University of St. Charles in 1844, there were well-paying, steady customers nearby.

Dr. Frederick Pond had recently moved from Chicago to the town of Earl, just forty miles west of Aurora, in 1870 or 1871. He boasted impeccable medical credentials from the Medical College at Cincinnati, the Bennett Medical College of Chicago (later to become Loyola University School of Medicine) and the United States Medical College in New York. His fascination for surgical cancer research was what had undoubtedly put him at the top of the suspect list for the desecration of Eliza Ann Bates. Several local doctors were also questioned about the grotesque grave robbery, but they each hinted at Dr. Pond as the most likely suspect. Whether this was from professional jealousy or sincere distrust was never clear. Dr. Pond was closely questioned and investigated during the grave robbing investigation, but no evidence was found to convict him. Though a $500 reward was offered to anyone who could provide the name of the individual who had committed this outrage, no one was ever brought to trial. Eliza Ann Bates was eventually reburied at Spring Lake Cemetery in a secret, unmarked grave to ensure that her body could not ever be resurrected again in the name of scientific research.

When Dr. Pond moved from Earl to Aurora in 1873, he put out his shingle as a general practitioner

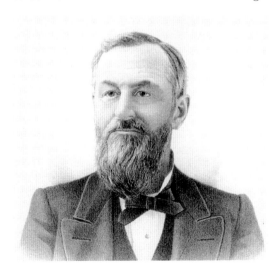

A portrait of Dr. Frederick L. Pond taken in 1888.
Courtesy Aurora Historical Society.

but also widely advertised that he had developed a remarkably successful cure for cancer. Desperate cancer patients came from all over to partake of his remarkable cure, and soon he opened the Aurora Medical and Surgical Institute to accommodate the steady parade of patients. The three-story, two-winged brick building could house up to three hundred patients and was a marvel of modern conveniences, including gas lighting, steam heat and bathrooms featuring that newest and rarest luxury: hot and cold running water. The *Commemorative Biographical and Historical Directory of Kane County, Illinois, 1888* by Pliny Durant describes both the institute and Dr. Pond in effusively glowing terms. However, its accuracy is highly suspect. For example, Durant, the admiring author of Dr. Pond's biographic article, describes the institute's setting as "extremely pleasant and attractive, enclosing extensive grounds that are carefully tended, provided with well-kept walks, evergreens and shrubbery…affording a most delightful retreat for patients while undergoing treatment." But Durant neglects to mention that this lovely park setting is actually Root Cemetery, directly adjacent to the new cancer hospital—a far-from-inspiring sight for terminal cancer victims hoping for recovery.

Ugly rumors had been circulating from the first about the doctor despite the amazing success rate he claimed for his cancer institute and despite his growing wealth and undeniable prominence in local business, church and society circles. The darkest gossip was that hundreds of Dr. Pond's cancer

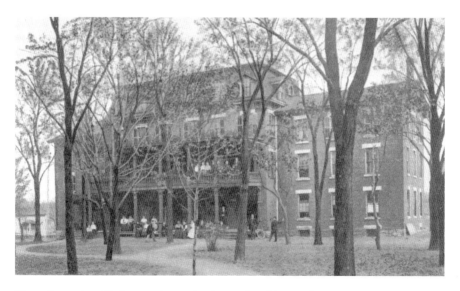

Shown here, circa 1907, operating as the Aurora Day Nursery, Dr. Frederick Pond's cancer hospital claimed miraculous cures. *Courtesy Aurora Historical Society.*

patients never left the institute "with the bloom of recovered health upon their cheeks, and hearts full of gratitude for the cure effected," as the 1888 directory article gushes. Instead, his peers whispered that Pond secretly buried his numerous failures and dissections in the dead of night at Root Cemetery, so conveniently located next door. Since no one could ever clearly recall to have ever seen a fully recovered cancer victim gleefully stroll out of the Aurora Medical and Surgical Institute—and because his miracle treatment and cure for cancer certainly isn't around today—the rumors could very well have been true. The skeletons of Root Cemetery were piling up.

Over the decades, Dr. Pond's Aurora Medical and Surgical Institute underwent some transformations. After the cancer center closed, it became the Aurora Day Nursery in 1907. It passed hands again and again, until the area's first building to boast hot and cold running water was finally torn down and replaced with a convent. This was followed by the Aurora Central Catholic High School and then by the District 2 Aurora Police Station, which took down the last part of the eight-foot iron fence. Today the building is home to the Aurora Community Center.

"A Deserted Marble Yard"

In 1866, the new Spring Lake Cemetery opened on Aurora's southeast side and quickly became the fashionable burial site for the wealthy and prominent. Relatives were dug up from Root Street Cemetery and moved to the more prestigious graveyard with even grander tombstones than before. The abandoned marble stones soon became targets for vandals, and the cemetery was neglected. On March 27, 1907, *Beacon-News* reporter Jack Remington wrote a brief history of Aurora's first public cemetery, describing its disgraceful condition as "a deserted marble yard." But it wasn't until 1928 when Lutz White, historical editor of the *Beacon-News*, wrote in his column that "Root Street Cemetery, in which were buried the pioneers of Aurora and a number of Civil and Spanish American war veterans, is in a run-down condition." His column shamed the community into calling for a large fundraiser to restore and repair the graves, furnish landscaping and lighting and surround the grounds with an eight-foot iron picket fence with handsome ornamental stonework at the corners and entrance ways at Grace Court and Flagg Street.

An official plat of the entire cemetery was commissioned and drawn up to establish who owned the various plots, which would also hopefully indicate who had been laid to rest there and where they might lie beneath the sod.

On July 15, 1930, the findings were submitted to the city council, reporting that a total of 222 single and double lots had been officially sold at Root Cemetery and presumably were occupied with the rather incomplete list of names they were able to compile from eight decades of poor recordkeeping and lost and destroyed records. According to the new official plat, such notable Aurora citizens interred there included the nationally famed Methodist minister Reverend John Clark and Aurora's first postmaster and Root Cemetery's sexton, Burr Winton. Some say that a decorated Civil War general was buried there among the other soldiers from America's wars, but this is not known for sure. To honor these and other early pioneers to Aurora, Root Street Cemetery was declared closed to further burials and immediately rededicated as Memorial Park.

Enthusiasm for the restoration project lagged as the Great Depression gripped the nation after 1929. As a manufacturing and entertainment powerhouse, Aurora was far more fortunate than most cities, but corruption, greed and indifference inspired misdeeds that were uniquely Aurora. Memorial Park had its new iron fence and ornamental cornerstones but was still heavily littered with the rubble of broken, abandoned graves that hadn't yet been cleared. There was a brief flurry of outrage when word got about that neighborhood boys were using blocks of the marble gravestones as bases for their baseball games, but that quickly settled down when the mayor finally ordered Park Superintendent Ray Moses to clean up the loose tombstones. What people

On Memorial Day, May 25, 2005, Aurora's Civil War veterans were honored with new headstones and an illuminated American flag in Root Street Cemetery. *Author's collection.*

didn't know was that the mayor had told Moses to take the costly marble monuments honoring Aurora's proud settlers and war heroes, crush them into rubble and use it as free land fill for the renovated golf course at Phillips Park! To this day, it is said that Phillips Park groundskeepers still find shattered bits of etched marble rock buried behind the pond and old pony ring, on the edge of the causeway and especially under the fifth tee at the golf course.

During the 1980s, Memorial Park once again became a field for death. Gang violence was rampant on the east side, and the former cemetery became a deadly shooting field as young men tried their best to gun their rivals down. Rumors still persist that an occasional fresh grave would be found there marking the place where a gang member had met an untimely end.

MEMORIAL DAY, MAY 25, 2005

On this day, a special solemn service was held at Root Cemetery to commemorate the final resting place for twenty Aurora veterans of the Civil War. Half had actually died during the war, while the rest survived the battles and went on to live their lives. Their service entitled all of them to receive special military headstones, each newly restored or replaced and now adorned with wreaths and standing in neat military rows. The American flag was run up the new flagpole to proudly wave over the honored dead. At long last, beauty, respect and dignity had come back to Root Cemetery.

Except for those Civil War memorials, only a few grave markers still stand today in the old Root Cemetery, each so worn and weathered that the inscriptions are unreadable. But while most of the gravestones are long gone, there is no doubt that hundreds of the dead yet lie there under the oaks. Just how many were left behind or secretly added to this soil may never be known. But as you walk across that broad field, do you notice how strangely uneven the ground is beneath your feet? There's a simple explanation. Before concrete vaults became mandatory for all burials, coffins were put directly into the bare earth. Eventually, a coffin would decay until the rotted wood would collapse under the weight of six feet of earth, and the coffin would quickly be filled—along with its grisly contents—with dirt. This would leave a coffin-shaped indentation about two to three feet deep on the ground's surface, which water and weather would eventually erode into a strangely uneven field beneath your feet. When you feel that on your stroll, you know that you're walking over dozens of old graves of the forgotten dead and disturbing the countless unsettled ghosts of Root Cemetery.

THE ELEPHANT GRAVEYARD

Aurora, Illinois, is a long way from the African veldt or the jungles of India. But you'd never know it judging by the surprising number of elephants that have died here.

The sad history of elephants in Aurora starts somewhere between ten and twenty-two thousand years ago, when three poor mastodons dropped dead in what later—much, much later—became known as Phillips Park. The first of their fossilized bones were discovered quite by accident on March 7, 1934, when workmen hired by the federal government as part of the New Deal economic revitalization program were excavating Phillips Park Lake. Mayor Townsend's hopes to have the lake named after him were dashed, as everyone immediately began calling it Mastodon Lake. The bones were originally displayed in the park greenhouse, then moved to the birdhouse and then at last to a permanent display at the Aurora History Museum in 1938. When the downtown museum location opened up in 1996, the mastodon display was relocated there, but in 2003 the bones were moved to the Phillips Park Visitor Center, where they are displayed today. In the summer of 2004, Waubonsee Community College led an archaeological mastodon dig, with dig expert Jim Oliver as the excavation field director. Scientists and students, as well as more than two hundred volunteers, sifted through a cordoned-off area with spoons and brushes for eleven weeks. While some exciting new discoveries were made, no new mastodons turned up.

While no elephant actually died on June 29, 1906, in Aurora, it was a traumatic day for elephants—and for people, too. The Barnum and Bailey

Circus Show was bringing its magic to the Driving Park, located north of Sunset and west of Palace Street in what is now called the Riddle Highlands Historic District. That morning, neighbors watched in awe to see the elephants helping the roustabouts raise the gigantic Big Top tent, lifting the massive tent poles with their trunks as the guy ropes were secured by men hammering in the tent stakes with huge mallets. Later, the downtown was thrilled as the elephants were paraded in the streets to whip up the excitement even higher, if possible, and drum up bigger audiences. It was a scorching-hot, humid day, but people came anyway from miles around, dressed in their Sunday best and chatting with anticipation as they made their way into the gaily striped Big Top circus tent. The last ticket was taken by the barker and all the tent flaps lowered and pegged so no one could peek in for free. Then the ringmaster started the show.

Before an hour had passed, everyone was absorbed in the nonstop action in the three rings before them. The beautiful women in gorgeous costumes finished the "Cloth of Gold" pageant, and the elephants came out next. But something was wrong. The elephants were obviously upset, trumpeting wildly, moving restlessly and swerving dangerously out of line. The elephant handlers had their hands full, and the trainer was trying without success to calm the enormous four-ton animals. But they seemed to sense that something bad was about to happen.

Suddenly, the air in the tent went ominously still, becoming so stifling hot that people could barely breathe. The sawdust that the elephants had stirred rose up as thick and heavy as smoke, and somebody screamed, "The grandstand's on fire!" The next second, lightning seared the sky directly over the tent, followed instantaneously by an ear-shattering whip crack of thunder louder than all the lions roaring together. To everyone's horror, the circular air vent flap at the topmost tent pole billowed up and down several times like a monstrous bird about to take off. Then, with a terrible roar and tearing noise, the entire top of the tent ripped right off, revealing an afternoon sky black with boiling green storm clouds swirling and twisting overhead. Without warning, a tornado had come down out of the sky directly onto the tent!

A torrent of rain cascaded into the Big Top like Niagara Falls, and pandemonium broke loose as the audience, circus performers and elephants tried to escape the enclosure. Huge tent poles fell toward the crowd, only to be caught on the guy ropes, swinging erratically like giant sailing ship booms as more of the tent was ripped away by the tornado. Men used any kind of knife they had on hand to slash the sides of the canvas tent, and people began to pour out of the tent and run to the nearest shelter.

The elephants saved the day. While most of the elephants were stampeding in terror, trying to find a way out, others grabbed hold of the wildly swinging poles, no doubt to prevent them from bashing into their heads. In saving their own hides, the elephants saved many human lives. Unfortunately, two people were crushed to death under the poles: a little crippled circus boy selling souvenir pencils and a legless man named Bury who couldn't crawl to safety in time. When the worst of the storm had passed, the survivors discovered that the storm had blown out the electricity, so the streetcars wouldn't run. Stumbling and shambling, they made their way south down Lake Street, their clothes tattered and soaking wet, some in glassy-eyed shock, others giggling uncontrollably with relief as they walked along. It was said that onlookers stood gaping at the ghastly sight, wondering if the end of the world was at hand and whether all of these hundreds of people had risen from their graves!

TWO DEATHS AT THE CIRCUS TENT

Further Details of the Destruction in the Driving Park During Course of Small Cyclone.

ACTS OF HEROISM ARE REPORTED

Brave Woman Tries to Resuscitate Louis Kress After He Falls to the Earth—How Elephants Were Taken From the Tent in Safety.

Headlines for the *Beacon-News* trumpeted the freakish occurrence at the circus. *Courtesy Aurora Historical Society.*

Aurora's worst elephant tragedy occurred late in the evening of July 10, 1927. The Hagenbeck-Wallace Circus had performed in Aurora, and the roustabouts and elephants had finally finished taking down the Big Top tent and packing up to leave for the next town. The entire elephant herd was being ridden across Lake Street just one hundred feet north of the Plum Street intersection when an inter-metro commuter train car suddenly loomed up out of the darkness and hurtled into the elephants at a high rate of speed. The screaming of elephants and men in the night was terrible to hear. Six people and two elephants received serious injuries, but an elephant named Ruth took the brunt of the blow. Ruth was killed, as well as her rider, a circus employee known only as Blackie.

It's been said that on every July 10 at the exact hour of the tragedy, if you stand just north of the intersection of Plum and Lake you can hear a distant echo of ghostly screams of elephants and men piercing the night.

PHANTOM OF THE
FOOD COURT

Downtown merchants scoffed when construction began on the massive, 1.5-million-square-foot Fox Valley Center in June 1973 amid the vast cornfields that divided Aurora and Naperville. What an absurd concept by developers Metropolitan Structures, Inc. and Westbrook Venture! Who in the world would drive all the way to Aurora's rural, remote southeast side to shop for mid- to high-end clothing and merchandise? There was nothing around it for miles—that is, of course, until their proposed planned community, the Fox Valley Villages, would be built. But who would want to live way out there, so far in the boondocks? It's common knowledge that people prefer to shop in the bustling, busy downtown Aurora stores that they had shopped at and trusted for generations. Everybody predicted that this "enclosed shopping mall" concept in the middle of the prairie was sure to fail spectacularly. A noted psychic even foretold that the Fox Valley Mall would collapse on the day of its grand opening, swallowed up into the secret, hidden glacial lake underneath it. Seizing an opportunity to acquire their fifteen minutes of fame, several intrepid photographers (among them my brother and his best friend) staked out positions at various points around the sprawling new shopping mall, ready and waiting all day for the first brick to crumble in hopes of capturing the prophesied cataclysm on film.

The only cataclysm that occurred that day fell on the downtown Aurora merchants. Anchored by the retail giants of Lord & Taylor, JCPenney, Marshall Field's and Sears, within two years the Fox Valley Shopping Mall posted sales of $115 million. The broad sea of paved parking lots was filled

with automobiles from towns coming from a forty- or even fifty-mile radius. The planned community of apartments, condominiums and offices called the Fox Valley Villages comprised the hottest properties in the far west Chicago suburbs, and soon a movie theater, restaurants, gas stations and other stand-alone stores cropped up in that magic mercantile circle bounded by Route 59, New York Street and winding Ogden Avenue.

As malls and then megamalls continued to sprout up across the United States throughout the 1980s, downtowns were abandoned, the streets and stores totally emptied of shoppers and life. The heart of the American community had been transplanted to the malls, and the economic devastation to the downtown merchants brought many to ruin. Desperate, Naperville risked a primary source of revenue by having all of the downtown parking meters torn out, making all downtown parking free, and built the stunning Riverwalk to entice tourists. It worked, but the merchants on and around Stolp Island were slow on the mark. Downtown Aurora sank into a hopeless economic depression, and many long-established stores went out of business or moved near the mall to survive. The railroad shops had already closed by 1974, followed by many other factories and industrial areas. Unemployment skyrocketed to 16 percent, and throughout the 1980s the downtown sidewalks and riverbanks bustled with other, far less desirable kinds of shoppers and merchants—prostitutes, pimps, street gangs, hustlers and drug dealers. It wasn't until Hollywood Casino launched its riverboats off Stolp Island on June 17, 1993—nearly twenty years after the opening of Fox Valley Mall—that downtown Aurora enjoyed a resurgence of its earlier prosperity, an urban renewal that has flowered into a full-blown renaissance today.

In early 2002, the prestigious Westfield Group bought Fox Valley Center and gave it the awkward name of Westfield Shoppingtown Fox Valley. Mercifully, the "Shoppingtown" was dropped by 2005. Lord & Taylor was replaced by Carson Pirie Scott in 1996, and on September 9, 2006, Chicago's beloved Marshall Field's stores were bought out by Macy's department store amid great controversy and fervent local boycotts that almost made the New York City retail empire back out of the Chicago area after its first crippling year.

The vast cornfields that once spread so grandly between Naperville and Aurora are gone now, sold for staggering amounts by the families who had farmed there for generations. The fields were then bulldozed over to make way for the endless rows of strip malls lining every street around the Fox Valley Mall. But one house did not fall to the wrecking ball. The Halfway House—so named because it was the halfway point in the two-hour carriage

ride between Naperville and Aurora—was built in the 1840s by Urbane D. Stanley. The two-story farmhouse of handmade red brick was always a welcome landmark to travelers, so when the mall was built, instead of tearing down the house, it was literally picked up and moved to the Naper Settlement Living Museum in 1975. Today, the Toys "R" Us store stands in the spot where the house once stood, just off the southeast corner of New York Street and Commons Drive.

There are rumors that a most startling paranormal entity has been witnessed at Fox Valley Mall. A glowing human torso—minus its arms, legs and head—has reportedly been seen floating in the food court in the dead of night. Supposedly, it is seen most often in the general area where the Sbarro, El Patron, Nori Japan and Arby's eateries are currently located, though it seems to be able to move anywhere down in the lower food court. This phantom's origins are easy to trace, arising from a terrible tragedy that occurred during the mall's construction. A worker fell from the scaffolding up near the skylights and plummeted to his death in the food court—right where the floating, luminous torso is said to appear.

Oddly enough, out of all the different bodily parts that have ever been said to manifest, floating torsos are surprisingly common. The ancient Greeks believed that the soul was seated in the core of the body, specifically behind the navel. Similarly, paranormal scientists theorize that energy is stored in the torso and radiates outward into our head and limbs. It takes a great deal of energy for an entity to fully materialize into a recognizable human form, and if the spirit lacks energy, the head and limbs are the last to appear. This could explain the many sightings of ghosts with legs of unformed mist, as well as headless ghosts. Very old ghosts are said to have lost so much energy over the span of years that they are no more than balls of light.

The night shift security guards and maintenance crew have their share of uncanny stories to tell. Long after everyone is gone, they've often heard voices talking in the back hallways that run behind the retail shops. These areas are restricted, and a key card is required to gain access. The guards will quickly and quietly move to catch the interlopers, but just as they reach the area where they could hear the speakers murmuring to one another, they'd turn the corner to find the hallway mysteriously vacant and silent.

CREEPY TALES OF SPRING LAKE CEMETERY

It's tempting to say that Spring Lake Cemetery is haunted. Bordered by Ashland Avenue, Broadway Street and Lincoln Avenue on Aurora's south side, it has all the hallmarks: nearly 150 years old; brimming with forbidding tombstones, empty-eyed angel statues, eerie monuments and locked family crypts; and shadowed by towering old oak trees over a rolling terrain. Spring Lake Cemetery is a city of the dead with more than twenty thousand residents and counting, including some of the most prominent old names in Aurora. If any cemetery should be haunted, it would be this one.

But is it? There are rumors of unexplained lights glowing among the graves; a ghost dog stalking the cemetery that comes out of nowhere to bark and howl mournfully; and glimpses of people in old-fashioned clothes walking in broad daylight who inexplicably vanish behind a monument and don't reappear out of the other side. One man swore that he saw a bride and groom in a trailing white gown and tux walking hand in hand among the stones before evaporating away into the night. Some of these accounts can be easily explained. Candles are occasionally left burning all night at the graves of those recently deceased (other items left almost daily at certain graves include bottles of beer and rolled joints). There *is* a dog—a ghostly white German Shepherd named Taz, owned by the Spring Lake supervisor who lives on the property, though Taz stays in his yard and doesn't wander the cemetery. The man who saw the bride and groom had been partying heavily all night, so he's not exactly a credible witness. And the people vanishing behind the monuments could easily be ordinary live

Spring Lake Cemetery is spooky enough to be haunted…but is it? *Courtesy Lisa Condinho.*

historians or genealogists simply stopping to read the inscription and take a rubbing of the stone.

Haunted or not, Spring Lake Cemetery has more than enough creepy tales of the nonparanormal kind to curl a listener's hair into knots. Following are a few that cemetery workers past and present have shared with me.

At the foot of the bluff along the cemetery road called Valley Drive, a caretaker found a roughly hewn wooden box about a foot long. Inside was a mutilated Barbie doll and a note. The doll's hands and feet were bound and then burned black and horribly melted. The eyes had been scratched out by a sharp object, the legs deliberately broken and the hair burned to a crisp. The note read, "This is to curse you for doing what you did to my child." No one on the cemetery staff saw the person who placed the box there, nor did anyone know what the note was referencing. They did know one thing, however; this box and its grisly contents were

surely part of a voodoo ritual to inflict a curse on somebody who may very well have deserved it.

Family mausoleums occasionally need a good cleaning in preparation for the next resident. Below the mausoleums are crypts and sometimes sub-crypts below those, where older coffins are sometimes moved to make room for the more recently departed kinsman. Certain crypts have only the patriarch of the family upstairs while everyone else is downstairs. These sub-crypts must be kept sanitized, too. Henry (not his real name) was a staff worker charged with performing this unpleasant task one afternoon, when his co-worker went topside to have a smoke break. Henry stayed below in the sub-crypt, mopping the crypt floor with a heavy-duty bleach cleanser. Suddenly, Henry had the disturbing sensation that he was not alone. He felt as if all the past family members ever buried in that black hole came out one by one to stand around him and watch him work, as if curious to see which member of the family was coming next. The uncanny, unnerving sensation was so vivid that he didn't even finish mopping but instead ran out of there fast and promptly quit his job at the cemetery. Was it just his imagination gone wild, alone in the deepest underground depths of an old mausoleum…or something else?

At one time, there had been two burial vaults carved deep in the base of the bluff along Valley Drive, but the graves were relocated and the vaults covered over when it was discovered that a homeless mother and her child were living in one of the vaults. This was probably during the Great Depression of the 1930s, when millions of people lost their homes and were desperate for any possible place of shelter. It's unknown how long they had made this tomb their home, but people had seen firelight glowing at the foot of the cemetery bluff even in the dead of winter.

The office for Spring Lake Cemetery stands to the left of the main gate. Part of it used to be a chapel, but now it is entirely used to conduct the business of the graveyard. But long ago, in the wintertime, when the ground was too hard for digging, the bodies of the recently deceased would be stored in the basement under the chapel until the first good spring thaw. It's no longer used for that purpose, of course, but no one, absolutely *no one*, willingly spends any time down in that creepy basement.

Halloween always means overtime pay for the caretaker staff to ensure that no thrill-seeker sneaks in to vandalize the valuable headstones. Several monuments in Spring Lake Cemetery are cast in a zinc alloy metal that appears grayish or blue-gray. During the 1880s, when they were popular, they were poetically marketed as "white bronze," but they are not bronze at all. While securely bolted to a stone base, these metal monuments are hollow and

Bodies were wintered under the old chapel at Spring Lake Cemetery, which is now the business office (at left of photo). *Author's collection.*

are occasionally opened up to clean the inside of debris and dead bugs that may have gotten in. One afternoon, a caretaker was doing this task when he got a wonderful idea. He left the hidden door in the monument slightly open. That evening was Halloween, and as he patrolled the dark grounds he saw intruders creeping around and giggling. The caretaker, who was a slight, slender man at the time, squeezed inside the hollow bronze monument and waited until the trespassers passed by—then he *jumped out screaming*! If those boys didn't piddle their pants as they flew out the gate, it would have been a miracle.

On a recent Halloween night, the head caretaker got the fright of his life when he heard a woman's bloodcurdling screams in the darkest part of the cemetery at midnight. This was no prankster—whomever that shrieking woman was sounded genuinely terrified for her life. He called the police, grabbed his biggest, heaviest flashlight and followed the ragged, unearthly screams to a hilltop. He turned on the powerful beam and swept it over the gravestones but saw no one. With an icy chill running down his back, he took several cautious steps closer and froze in terror when two pairs of eerily glowing amber eyes stared back at him from behind one of the larger tombstones. He nearly jumped out of his skin when the glowing orbs suddenly leapt up and vanished…and that's when he saw that it was just a pair of coyotes, wooing and screeching their love songs to each other in the graveyard at midnight on Halloween night.

Spring Lake Cemetery definitely has its share of disturbing, scary stories all right. But are there any *real* ghosts there? There might be two. The

On rainy days, a mysterious ghostly woman in a shawl has been spotted on this hill in Spring Lake Cemetery. *Author's collection.*

administrative staff members sometimes wonder if the cemetery's longtime office manager, Mrs. Swanson, might still be around. She had worked there for thirty years before passing away. She's buried in Spring Lake, of course, but the staff have noticed that every time anybody speaks of her, there's one particular light in the office that starts to flicker, as if her spirit is acknowledging their fond memories of her. Curiously, one chandelier in the old chapel will also swing back and forth of its own accord, while the second chandelier a few feet away will remain still.

The other genuine ghost sighting is that of a pretty, middle-aged woman standing on rainy days on a hill off Lincoln and Ashland. She wears a long "granny-style" skirt and a light-colored blouse with a shawl wrapped around her. She looks out over the river with a daydreaming expression on her face, as if she's anticipating the arrival of someone she dearly loves. She has been seen multiple times by drivers passing by on the street, but when they look back in the mirror or turn around immediately and drive back for a second look the woman is gone. No one knows her story or identity. Just like all of the other souls at rest in Spring Lake Cemetery, her story is done.

OUR SAVIOR LUTHERAN CHURCH

The midnight shift at the Aurora Police Department gets the most bizarre cases. This true story was told to me by former police detective and former deputy coroner Mike Dabney, who worked at both jobs for a total of twenty-eight years before his retirement, three years of which were on the midnight shift. On a stormy night in 1989 or 1990 at the Aurora Police Station, the alarm for the Our Savior Lutheran Church on Downer near Chestnut went off. A team was dispatched to search the church and parish house but found nothing. They shrugged the incident off. Electrical storms often set off building alarms, though they had never had a false alarm at the Lutheran church before. At 2:00 a.m., the alarm at the church went off again at the police station. When there are two alarms at the same place within hours of each other, it's a good bet that somebody's broken in. Six police officers descended on the church and searched the entire place but found no one, nor was there any sign of forced entry. The six officers gathered in the Parish House to confer. The beautiful Parish House, with its Tiffany glass window, is an eclectic blend of architectural styles—Queen Anne, shingled villa and Colonial. It had once been home to the Kilbourne family, who owned the Fox River Butter Company.

Suddenly, all six police officers clearly heard the tread of a man's footsteps above them crossing the entire length of the second floor. Sometimes an old house will creak and settle, sounding much like footsteps, as the wood expands and contracts with changes in the weather. But this wasn't one of those times. They could easily tell that the *thump-thump-thump* of footsteps

were accompanied by, but clearly separate from, the usual sounds of wood creaking under a man's weight. The team divided into two groups of three and then ran up the two staircases at either end to trap the intruder. There was no other way out from there for a man to run, no possible way to escape since they were coming at him from all sides, but to their utter astonishment, no one was there. The police searched every nook, cranny and closet, but whoever had made those distinct, confident footsteps had inexplicably vanished.

"PAULA" OF WHITE EAGLE

A historian's greatest thrill is to receive a firsthand eyewitness account from out of the blue that corroborates the true facts behind an old wives' tale of local lore. I had heard from a number of sources that a section of the White Eagle subdivision on Aurora's far southeast side is haunted. Frustratingly, though, no one could ever tell me any particulars of the hauntings, so I filed the tidbit of information away, knowing that I couldn't legitimately present the case until I had more solid facts in hand. It was on the afternoon of December 31, 2008, when I received an e-mail with the subject line of "White Eagle subdivision." I assumed that someone was having a New Year's Eve party and at the last minute decided to hire me to tell Christmas ghost stories or read Tarot cards for their guests to learn what's in store for them in 2009. Imagine my thrill when I opened the e-mail and found a New Year's surprise. The following e-mails between Natalie (last name withheld by request) and me are published here with only very minor edits.

From Wednesday, December 31, 2008, 2:23 p.m.:

> *Hi Diane,*
> *Not sure if you have any insight for me but I figured this was worth a try.*
> *I found your site while doing some research on hauntings in Naperville. My*
> *parents built a house in White Eagle in 1989 and we lived there for about*
> *10 years. The house we lived in was brand new so whenever we would tell*

anyone about the odd things that happened there, we were told there was no way it could be haunted because we had built the house and no one had ever died there.

Around the corner from us lived another family who, like us, had custom built their home. They were just as adamant as we were however, that their home was also haunted. Years ago we tried researching the land and there were always rumors that the subdivision had been built on an Indian burial ground, although proof of this was never found.

My parents…lived in the original house for a while but my stepmother never felt at ease there, so [they] *had a second home built in WE in the early 2000s. They lived in the second house for about three years. I was recently talking to my stepmother and she admitted that she had experienced very unsettling encounters in both houses and that was why she eventually pressed my father to move from White Eagle all together.*

Sorry to ramble—(I am getting to the point of my note now)—in your experiences, have you ever come across anything suggesting that this entire subdivision is haunted? The community was built in phases and the house we built as well as the friend's house I mentioned were built in the first phase and are located in the center of the subdivision. The second house my father built was in the 3rd phase most likely and is located on the west side of the subdivision, closer to Route 59. I have not heard of anyone residing on the east side of the subdivision that has experienced things similar to what my family and friends have seen.

If you have any information about this area, I would be greatly curious to hear about it, both to validate what we have experienced and also to share with the others who have seen and experienced things in this neighborhood.

Thank you very much for your time. Natalie

From Monday, January 5, 2009, 2:25 p.m.:

Hi Natalie;
Sorry it took me awhile to get back to you. I was waiting to hear from my historian friend at the Naperville Settlement about White Eagle. Here's what he had to say…

"The original land was settled by various families including Rev Isaac Foster, Chester Ingersoll, and Joseph Wightman. Others included 'Hoosier' Smith, David Cheeny and a man named Eddy (last name). These people settled in mid to late 1830s. In the 1840s a large group of Scottish immigrants settled in Wheatland—notable are the Clows, McMickens,

Cottons, and Robbins. The names of those who pre-empted the land (bought from the government for $1.25) included, James Congrave, Jacob Crapery (may be Cropsey), Benjamin Hackney, John Johnson, Mark Kimball, Daniel Mickey, and Jacob Witchey. Real settlement of the prairie and timber of Wheatland Township occurred after the Civil War, post 1865. The only mention of Native Americans in the township is an old Indian trail—but no campsites or villages are recorded here."

Natalie, I have heard only the vaguest possible rumors that the subdivision is haunted, but could never get any specifics, stories or eyewitness experiences. Would you be willing to tell me everything you've heard and/or experienced about the hauntings? If you wish, I can guarantee complete anonymity and the utmost discretion—I wouldn't be in business long if I didn't know to keep my mouth shut about people's haunted houses, so ensuring your privacy is in my best interests as well. You can either send it in an e-mail, or we could meet for coffee. Any possible way I could get inside the houses?

Don't believe that just because a building is brand new that it can't be haunted. If a ghost is "grounded," that is, tied to the land more than to the building, it certainly can occur. Three ghosts haunt the Wal-mart on Route 59. And there's a house in Lisle owned by a retired couple who will return home to find children's footprints in the vacuumed carpet, but only in a small portion of one room—in the area immediately around and under the dining room table, and nowhere else! Not a single footprint leads to or from the doorways or into the corners, or extends anywhere past a few inches beyond the circumference of the table. To further compound the mystery, the legs of the table and chairs stand inside the prints, as if the furniture wasn't there while the ghostly children played! Perhaps the children see the walls of the old farmhouse that used to stand there, and so stay only in that small space.

Another possibility is that some item in your stepmom's house has a spirit residue associated with it. You've heard of antique dolls with the ghost of its owner haunting it? It doesn't have to be a doll, it could be a piece of antique furniture or antique china bowl, etc. May I include your name on my Eerie E-Newsletter mailing list? My next issue features a book on "Possessed Possessions" that you may be interested in.

Hope to hear your experiences soon! –Diane Ladley

From Friday, January 16, 2009, 2:21 p.m.:

Hi Diane!

I have finally finished talking to my family members to get their recollections of things that happened at [the home on] *White Eagle Drive. I apologize that it has taken so long. The scariest thing that happened to me was also the first odd event I remember taking place. I was in my bedroom, and I was sleeping. Something woke me, didn't know what. I was lying on my back. I opened my eyes and there, about 2 inches from my face, was another face peering down at me. Whatever it was, it was hunched over, peering into my face, just studying me as I slept. I remember it was white and kind of transparent, and was just looking at me with curiosity. I rolled over onto my side, threw the covers over my head, and just sat there for God knows how long before I fell back asleep! I was too scared to get up out of bed.*

There were so many other times that our dog would stand in the upstairs foyer and bark into my parent's room. He would sometimes go into the room and stop at the bathroom door and would bark and bark like mad into the bathroom. But that dog NEVER would go into the bathroom. He was scared of it.

Lots of times I saw her, (I always thought it was a she), just floating around the house. I would be in the living room and look over into the kitchen and she would be standing at the island. Other times you would see her going from the kitchen around the corner to where our pantry and laundry room were. It was no use following her; she would be gone by the time anyone got there. Or, you could be at the bottom of the stairs and look up and see her on the stairs or in the upstairs hall. Once my sister and I were in my parent's room watching TV and we both saw her go into my room. The dog started going crazy. She looked at me and said "Did you see…?" and I said… "that person just go into my room?" "Yeah!" We both had seen it at the same time.

Then there was the time the balloon floated. It was right after one of my sisters had turned 16 and we had blown up some balloons, (with our own breath) as decorations. Afterward I ended up with one of the balloons in my room for whatever reason. I remember the balloon was on the floor in my room and all of a sudden it rose up. It got higher and higher and finally hovered in the air right about at the height my face would be. I started screaming for my sister in the next room. She came out just in time to see the thing DROP. Not float lazily down from mid-air back onto the ground, but it literally DROPPED to the ground like someone was holding it and had

forced it down. Another time I was in that room and a tape cassette flew off my stereo and flung itself about 3-4 feet across the room, for no reason.

My best friend remembers the time we were sitting at the kitchen table, and the way the house was set up, the kitchen opened into the living room. My parents were in the living room and we were in the kitchen. I had a drink on the table and the cup started slowly moving across the table by itself. We got up and ran to my mother, who looked over in time to see it still moving. My father, always the skeptic, blamed it on condensation.

There was also another time with the same friend when we were there alone. We had the stereo in the front room playing, and we were cooking in the kitchen. When we sat down to eat, the stereo suddenly turned up FULL BLAST. We looked at each other, got up, and ran right out the back door. We ran around to the front of the house and tried to peek into the window where the stereo was. We couldn't see in, because of the curtains, but could clearly hear the music blaring. It took several minutes for us to get enough courage to go back into the house and shut off the music!

She also reminded me of the time when one of my sisters was in the bathroom and the shower was running. For some reason, we kept banging on the bathroom door trying to get her to hurry up. After [two or three] times pounding on the door, my sister—who was supposedly in the shower—came out of her bedroom and yelled at us to stop banging on the bathroom door. We just looked at each other and went to the bathroom and flung the door open. The shower was not on, there was no one in there, and everything was dry. THAT was weird.

My mom…had an experience once when she was reading in her bed. A girl walked into her room and proceeded into the bathroom. She thought it was me and said, "What are you doing, Sweetheart?" When I didn't answer and didn't come out, she got up and went in there—but of course there was no one there. She was scared because she had seen ME walk into her room and right past her! She was awake the whole time! I remember her coming and asking me if I had gone in her room, and I hadn't.

Another thing that happened, (and I never really felt this was because of the supernatural, but probably from the builders who built the house), but after we had lived there for a year or so, my mother for some reason had an inkling to look into the crawl space that was accessible from her room. Inside the crawl space were several small bones. We chalked them up to chicken bones. We never knew where they came from or why they were there. One of my sisters thinks that Paula, (our name for our spirit), put them there. But I never believed that because she never did anything odd with food or "hiding" things that we were aware of.

We did have a Ouija Board, and that was what gave us the name Paula. I remember asking the board if it was male or female, if it wanted us to leave, and what its name was. Per the board, it was a she, named Paula, and she did not want us to leave. I don't, however, put much stock in those things as I think more times than not someone is pushing it around. But I never did feel she was there to harm us.

There have been so many people who came to that house and told us they did not feel comfortable there. We had a couple of friends come to stay with us for a bit. They were supposed to stay at least a week. After three days, however, they told us they could not sleep another night in the house because it scared them too much and they left early.

Some people couldn't put their fingers on it, and others would say the house had a bad vibe. I loved the house. I always felt safe there and like, it was my home. I was somewhat afraid to be alone there but it wasn't so much because of the spirit as it was me being afraid someone would break into the house. I would love to get inside that house again just to feel it out and see what it feels like. I assume if she is still there, she would recognize me. I wonder if she would try to make contact? That was my childhood home, and haunted or not, home is where the heart is!

I would not mind if you made these stories public. You can use my first name, but please do not use my last…you know how skeptics can be! Please let me know if anyone else comes to you with White Eagle stories. I would LOVE to hear them! Thank you for listening to our tales! Take care. Natalie

From Monday, March 30, 2009, 4:13 p.m.:

Hi Natalie;
It's my turn again to apologize for not getting back in touch with you sooner about your family's ghostly experiences. I'm blown away! These are so cool! Wow—I grew up in a boring, ordinary house in Naperville. I'm envious! :-) Thanks for sharing! −Diane

THE LIBRARIAN'S TALES
AND DO-IT-YOURSELF GHOST-BUSTING

So, you think your home is haunted. Who you gonna call? (Cue the *Ghostbusters* chorus.)

No, seriously. Who can you turn to for information, reassurance and help to get rid of a pesky poltergeist? Heaven forbid that you confess the weird things you've seen to a friend, only to have her avoid you in the future and tell the neighborhood that you're crazy! And if the whispers and finger-pointing became unbearable, you couldn't even move away—who would want to buy a house that everyone knows is haunted? (Actually, any number of people would jump at the opportunity. Mary Pope-Handy, a realtor out of California, posts a bulletin board of helpful articles and listings for haunted and stigmatized properties on her website www.hauntedrealestateblog.com. You'll find listings for sellers and for buyers who are "seeking a home with a little something extra." Check it out; it's a very informative site.)

If you suspect that a ghost is infesting your home, you may feel all alone, with no one you can trust to turn to. Perhaps you even feel as if you and your family are in danger from an angry or otherwise negative spirit. (I personally do not believe that evil demons from the netherworld are haunting a site, as said by so many paranormal TV shows that love to frighten us. But I do believe that ghosts can be angry, hostile and even harmful, just like any living person.) But you are far from alone. Many other people, right in your community, have this exact same problem, and help is close at hand—in fact, it's as close as your local librarian.

THE AURORA REFERENCE LIBRARIAN KNOWS ALL

"People ask me about the history of their houses all the time," says Charles Coddington, one of the reference librarians for the downtown Aurora Public Library. "My first question I ask them is, 'Is it haunted?' Nine times out of ten their answer is yes." Charles has heard so many first-person accounts of Aurora's haunted houses that he toyed with the idea of writing a book about it. But, with few exceptions, most of these homeowners aren't looking for their paranormal problem to become public knowledge. Their request for help is more along the line of a private confession, and Charles respects that unspoken understanding. He was comfortable, however, with telling a few nonspecific, anonymous stories of people who had come to him hoping to learn the following identities of their amorphous houseguests.

- A couple who just purchased a big old house on Benton Street near Fourth Avenue were alarmed to see the apparition of an old woman still lingering around their place.
- A family living near Terry Avenue and Short Street on the near north side is regularly visited by a ghost, even though the house is less than forty years old.
- A woman didn't believe her child's tale about a ghost in her bedroom until she walked in late at night and saw an old lady standing at the foot of her child's bed tenderly smiling down at her—before vanishing into thin air.
- A family on Jackson Street lost the services of their best babysitter because she was terrified that the doors kept opening and closing by themselves, so she's never coming back in the house again.
- A young boy saw a shadowy male figure swathed in a black cloak with glowing red eyes staring at him from out his bedroom window—on the second floor. When he told his mother what he saw at breakfast, his older sister dropped her spoon and said, "You saw him too? He was at my window! I thought he was just a dream!"

Charles doesn't think these people are crazy. Quite the contrary; the fact that they're going out of their way to seek help and advice indicates to him that they're dead serious about what they've experienced in their home. He's always happy to dig into the library's myriad files on Aurora's houses and neighborhoods and is occasionally surprised at what he uncovers for the homeowners. If Charles can't find any information on a particular house, he

directs them to the Aurora Historical Society and suggests a book or two that might help them understand their unusual problem a bit better. Now that he's gotten to know me (and trusts that I'm not a crank), he also gives them my name and contact information as well. While I can't exorcise ghosts, I can certainly put them in contact with the right people while keeping their secret safe. Blabbing about other people's ghostly sightings is the fastest way to ruin a haunted historian's reputation, so if I ever want people to talk to me again, I keep my mouth snapped shut and the story off the page if they don't feel comfortable about it. You'd be surprised at the number of haunted homes in Aurora that are not in this book or on my tours—nor will they ever be.

So, you've spoken to Charles at the Aurora Library about your ghost, and he may have been able to give you a clue or even a likely candidate as to the identity of your ethereal houseguest. Now what? Let's take a moment to look at what options are available to the hapless haunted homeowner.

What to Look for in a Psychic Ghost-buster

You could try a psychic, but you'll soon discover that communicating with the dearly mostly-departed is a special branch of mystical talent that not all psychics can claim to possess. For example, a psychic who advertises that he's a psychokinetic retro-cog won't be able to help you with your ghost problem, but they'd be ideal for moving a small object with their mind and seeing your past lives. For help with your haunted house, the types of psychic abilities to look for are:

- Psychic medium—one who has the ability to literally see dead people. A terrifying and rare gift, a true medium often has multiple related skills that can provide you with the most static-free connection to the ghost in your closet. Also called a spiritualist.
- Channeler—a psychic medium who willingly allows spirits to posses his body, using him as a conduit for messages.
- Psychometry—psychics with this ability are able to know about a person simply by picking up impressions from either an object that they once wore, a photograph of the person or a place they had been. A psychometric psychic can hold your Aunt Tillie's old necklace and identify her as the spirit who's haunting your house. Also known as psychic investigators, a person with this talent is sometimes used by police to open up new leads in a criminal case.

- Empath—one who can sense a ghost's emotional energy and tell you what the ghost wants. Usually, if you are able to give the ghost what it wants, it will go away, even if it wants something insignificant. A great example of this happened to a friend of mine, who came upon his grandmother every night in the kitchen with a frustrated, worried look on her face—every night *after* she had died. At a psychic's suggestion, he set out some warm milk for her, because in life she always drank a cup before bedtime. Comforted at last to find her milk prepared for her as usual, she was able to finally rest in peace.
- ESP or the five "clairs"—clairvoyance, clairaudience, clairalience, clairkensis (or claircognizance) and clairsentience—describes the psychic power to, respectively, *see* what is hidden, *hear* voices from other planes of existence, *smell* aromas from a spiritual source, *feel* the presence of angels or spirits in the room and *know* forgotten or lost information in the form of a sudden insight.

Many psychics and most Wiccans (good witches) and shamans can cleanse or "smudge" your home free of spirits with rituals and prayers, though it may take several attempts. Be aware that psychics will want to get paid, and while many psychics deal in an honest, ethical business manner, there are some who'll make the money in your bank account vanish and not the ghost. Check their references thoroughly.

WHAT TO EXPECT FROM PARANORMAL INVESTIGATION TEAMS—GHOST HUNTERS

If you're the type to feel that psychics are a bit too "woo-woo" weird for you, a more down-to-earth alternative is to search the Internet for paranormal investigation clubs in your area. Dozens of ghost hunting groups have sprung up like mushrooms since the premiere of the television show *Ghost Hunters* on the Sci-Fi (now Syfy) Channel. The honest operations will not only refuse to accept any money but will also gladly sign liability waivers and written assurances of discretion that will hold up in a court of law. That's great, but sadly there are some groups out there who are unprofessional and less-than-objective in their observations. Beware the drama queen investigator who promptly claims to be possessed by an evil spirit and swears that your home is infested by demons out to get you. Raise the red flag if he gets overly excited by a streak of light captured

in a digital photo and insists that it's a ghost in the form of pure energy rather than the more obvious explanation of a mosquito caught in the camera flash.

But even if you find a professional, no-nonsense, paranormal investigation group with their protocols firmly planted in scientific rationale, homeowners are often unpleasantly surprised to learn that they usually cannot get rid of the unwelcome phantom for you. The purpose of a ghost hunting society is to tell you either that the noise that sounds like footsteps on the stair is actually a loose pipe fitting or to tell you that no, you're not crazy, your house really is haunted. If it's the latter, their fondest wish is to come back and investigate your home night after night, as often as you'll let them. The ghost hunters may advise you on what you can do to send the spirit to its final rest, but few will offer to do it for you. Some even insist that you, as the living home dweller, are the only one who can do it. Reputable ghost hunters provide a valuable service to the haunted homeowner, but if you expected them to exorcise the ghost, you probably made the wrong phone call.

TIPS FOR THE EXORCISE-IT-YOURSELF HOMEOWNER

Here's a ghost-cleansing ritual I learned from a woman who is both a psychic and a Wiccan, so if you think your house is haunted and are willing to give anything a try, here you go. It's nondenominational and is supposed to be effective for everybody from agnostics to Zoroastrians.

Step 1: Close up every possible exit a ghost can take out of the house: front door, window, fan vents, fireplace chimney flue, etc. Don't forget to check possible exits in the attic and basement (it's strongly suggested that you do this ritual in the daytime).

Step 2: Start on the top floor in the corner of a room. Some psychics suggest starting in the corner of the most northwestern room and finish in the most southeastern room, but if you're as directionally challenged as I am, don't worry about it.

Step 3: Light a cone of incense or a smudge stick and move clockwise around the room. A smudge stick is a handheld bundle of herbs, usually sage or rosemary, traditionally used in American Indian purification rites. It's the fragrant smoke that matters, however, not the flavor or form of incense. Open all of the interior doors and smoke them, too, including closets, drawers, cabinets and pantries. Speak aloud as you do this, telling the spirit—not asking, *telling* it—to leave this room and never return. Feel free to make it as prayerful or prosaic as you wish. Be firm and confident,

but don't swear at it. You want it gone, right? And you don't want it ticked off at you, right? No swearing.

Step 4: As you circle the room, sprinkle a bit of salt in every corner. Mounds are not necessary—just a few grains will work perfectly well since you may want to keep it there for as long as a week, and piles of salt might be awkward to explain to friends and family.

Step 5: When you get back to your starting position, repeat your request to leave this room and never return and then head out the door to shoo it out with a no-nonsense, I-really-mean-it stride.

Step 6: Repeat steps 3 through 5 in every room on that floor. Leave all of the interior doors open as you do. Finish up with the hallway and stairs. Put the salt at the top and bottom of the stairs—no need to season every step. Repeat the process in every room on the next floor and the next, all the way to the basement, but leave the ghost an "escape route" leading toward your back door. This is critical! If it has no way to leave, it's going to be stuck in your house and mad about it, and that's the last thing you want.

Step 7: In the last room, prop open your back door (yes, the screen door, too) and repeat steps 3 through 5, chasing the unwelcome spirit out of the house. Command it to move on and never return to this house again and then shut the door before your neighbors can stare out their windows at you. To avoid any similar confusion with the postal carrier, be sure to use the back door and not the front.

Good luck!

THE STRANGE CASE OF THE LINCOLN MURDERS

Though no known ghost legend arose from the shocking incidents of Aurora's most sensational murder, the gruesome and bizarre events are worth a quick paragraph in this book. The following is excerpted with the gracious permission of Curt Morley from his chilling audio CD Fox Valley Phantoms.

In the spring of 1923, a lawyer and horticulturist named Warren Lincoln turned up missing. The Aurora police investigated the matter and found his home, which was located in unincorporated Kane County, in disorder. Numerous bloodstains were found in the residence, and the investigating officers came to the conclusion that he had been murdered by his wife, Lina Lincoln, and her brother, Byron Shoup, who were also missing. Shortly thereafter, relatives of the accused woman began receiving typewritten notes asking for money. They were posted from several rural Illinois communities and were signed with her initials. Several months later, Warren Lincoln was found to be very much alive…and willing to confess to the murder of his wife and her brother. After he had killed them, he cut off their heads and disposed of the rest of the remains in a greenhouse furnace. He then mixed up some cement and placed their heads in a block. The faces of the deceased could clearly be seen in the block's surface. He used the block to prop open the door of his sleeping porch. He eventually threw it into the town dump, but the Aurora police recovered it. Warren Lincoln spent the rest of his life in prison. The block—with the heads of his two victims—was put on display by the

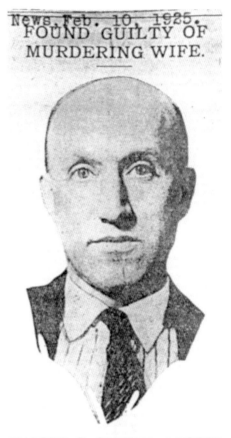

News, Feb. 10, 1925.
FOUND GUILTY OF
MURDERING WIFE.

WARREN J. LINCOLN, LAWYER
AND HORTICULTURIST, WHO
WAS CONVICTED BY JURY IN
GENEVA COURT. LIFE IMPRIS-
ONMENT WAS THE PENALTY
FIXED BY THE JURY.

Headlines from the February 10, 1925 *Beacon-News* announcing Warren Lincoln's sentence for Aurora's most horrific murder. *Courtesy Aurora Historical Society.*

Aurora Historical Society; but it mysteriously disappeared years ago. No doubt it will turn up…eventually.

Note: The home of Warren and Lina Lincoln used to stand on what is now Old Indian Trail Road. It was razed in 1999. No rumors of it being haunted have yet been found.

PAUPER'S FIELD

Perhaps the saddest, most mysterious cemetery of them all is located on Montgomery Road and Fourth, just east of the St. Paul's Lutheran Cemetery on Aurora's far south side. Below this broad strip of field are buried 218 people, though you'd never know just by looking at it. There are no headstones or markers of any kind—just a black marble monument erected on September 13, 1996, adorned with pretty silk flowers and the American flag flying from a tall flagpole above it. Carved on the marble slabs are the names of all those who are buried there—or at least, those whose names were known. This is the Aurora Township Cemetery, known as a pauper's field, the place where all those who were homeless, lost and penniless when they died are laid to rest.

Reading down the list from no. 1 to no. 218 is a sobering experience, offering intriguing hints of the pathetic and wretched lives that these pitiful victims led, as well as their lonely, tragic deaths. The first internment was a one-year-old child who was abandoned and died in 1931. The last was forty-five-year-old Donald L. Hicks in 1979. A disturbing number of the carved names are marked simply as "Unknown Man" or worse, "Unknown Infant." Even more heartbreaking than that is grave no. 139, "Unknown Infants," plural. What was the terrible story behind the triple deaths of the Duran family, no. 203, no. 204 and no. 205 on the monument? Daniel, age twenty-five, Irma, age four, and one-year-old toddler Patricia all died together in 1974. Many of these poor people were hobos who had died in railroad accidents and ended up here. No. 22, "Unidentified," is where a

The Aurora Township Cemetery monument bears the names of 218 people buried here who died homeless, penniless and unknown. May 2010. *Author's collection.*

handless, headless, badly burned body had been interred. The *Beacon-News* of May 2, 1923, reported that these mutilated remains were found on a desolate Geneva road. The coroner's office had the body for several weeks in the hopes that someone would claim it, but no one ever stepped forward. Eventually, the remains were buried and then relocated to this field. From newborn babies and men and women in the prime of their life to senior citizens all alone in their last years, they all lie here together in this meadow, unfortunate victims of a cold, cruel world.

On rare occasions, the identity of one of these forgotten souls is revealed with the help of modern science. On March 23, 1944, an unknown person who had been pulled from the Fox River was disinterred and claimed after dental records matched up with the skeleton's teeth and jaw. This body

proved to be that of Edgar Walsh of Chicago, who had escaped from the Elgin State Asylum the year before. His name isn't on the marble monument since it was a recent addition, but he was considered a success story.

I've visited the Aurora Township Cemetery three times while conducting research for my book. The ground is very uneven underfoot where the simple pine boxes of paupers have decayed, leaving rectangular-shaped patches of greener, lusher grass. On two of my visits, the sense of melancholy and loneliness was strong, but on the second visit I felt an overwhelming sensation of bitterness and anger roiling out of the earth. I kept envisioning skeletal hands reaching up from the unmarked graves trying to grab my ankle and drag me down below. That bright, sunny afternoon in the cemetery gave me a bad case of the crawling creepies that didn't fade away until I retreated back to my car. On that same afternoon, however, I noticed tiny white moths fluttering here and there where I stepped among the diminutive yellow flowers that grew wild in the grass. It was a pretty sight and helped to get my mind off the intense atmosphere surrounding me on that day. The next time I visited, there were tiny, white, fluffy cottonwood seeds drifting over the calm field, reminding me of the white moths from before. I dismissed it as a minor coincidence, until I recalled that on my first visit to the Aurora Township Cemetery the previous winter, fat, fluffy, white snowflakes had been quietly falling from the sky. Three visits…three, beautiful, pure white acts of nature. Or could they have been *super*natural acts? In some American Indian and Asian cultures, white moths are supposedly the souls of people taking on this form to fly to heaven. Could the white moths, cottonseeds and snowflakes have been the sorrowful souls still drifting over the field where they lay? It's a lovely, though very sad, thought.

AURORA'S TOP FIVE
EERIEST PLACES

Here are five miscellaneous sites in Aurora that are rumored to be haunted but either have no specific story, decent evidence or background history to qualify them for full chapter status. They're arranged in ascending order from the mildly eerie to the "oh my God you don't ever want to go there at night" eerie.

AURORA HOTEL

Built in 1917 in the Second Renaissance Revival style by architect H. Ziegler Dietz, this eight-story concrete and brick structure was the tallest building on Stolp Island until the Leland Tower. Saved and restored by a grassroots movement in 1996, it's now the North Island Apartments for senior citizens. The Aurora Hotel has the distinction of having housed the scientists who broke the German spy code in World War I. Reports of paranormal activity include strange mechanical creaking noises that can neither be tracked to a source nor explained. Shadow figures have been seen walking down the main stairs, and occasionally the lobby atmosphere is said to be charged with an inexplicable aura of a waiting and watchful though wholly benign presence.

BAYMOUNT INN AND SUITES OF CHICAGO/AURORA

Off I-88 at the Route 31 exit is the Baymont Inn and Suites. Several strange accounts of paranormal activity have been reported there. Late one night, two people—an employee and a guest—both heard voices coming from a room that had no registered guest assigned to it. When the door was opened, the voices immediately stopped, and not a single living soul was in the empty room. On another night, a guest came down to the lobby in his pajamas and robe. He had been asleep in room 208 but claimed to have been rudely awakened by an unseen presence strangling him while he slept. The guest, quite understandably, wanted a new room. Then on St. Patrick's Day 2001 at approximately 2:00 a.m., both the front desk clerk and a guest witnessed a white ball of light shooting out from the office into the lobby before it disappeared.

MOUNT OLIVET CEMETERY

Across the street from Spring Lake Cemetery is Mount Olivet Cemetery. It's a Diocesan Cemetery of the Diocese of Rockford and services the parishes of the Fox Valley. The land was originally part of the Daniel Bloss farm, as was Spring Lake Cemetery. Bloss died in 1871 and his widow inherited it. The land changed hands and was to be subdivided into lots, but Aurora's Catholic community from St. Nicholas Church (German) and St. Mary's Church (Irish) acquired the land. In 1887, it was conveyed to the diocese to be a Catholic cemetery. The first burials on the site are said to be prior

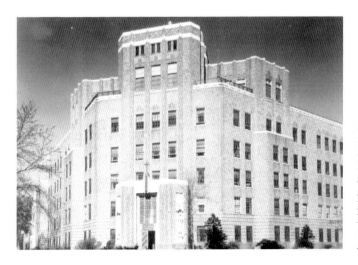

Built in 1931, the former St. Charles Hospital is now a sanatorium and nursing home, pictured here circa 1950. *Courtesy Aurora Historical Society.*

to 1850, but these were probably people who had died earlier and were relocated to the "new" Catholic cemetery. The haunting reported here is brief and mysterious. A 1958 Lincoln Continental drives up to the front gates, and two women in 1950s-era clothing get out. Suddenly they and the car simply fade away.

St. Charles Hospital/Fox River Pavilion

The original St. Charles Hospital building was established in 1902 on the corner of New York and Fourth but was replaced with the current Art Deco–style building in 1931. Currently it's a nursing home and sanatorium called the Fox River Pavilion. On June 7, 2010, it was added to the National Register of Historic Places.

Everyone of whom I've asked, "Do you know of any haunted locations in Aurora?" has unfailingly mentioned the old St. Charles Hospital with a shudder. There's only one odd problem—no one is able to tell me why they believe it to be haunted. It's just one of those cold, mysterious places and simply doesn't feel right. It has a history of murder and suicides; one particularly gruesome suicide occurred when a deeply depressed man jumped off the front roof of the building but landed on the pavilion over the main entrance doors where no one could see him. It was days before they figured out where he had gone. There is a rumor that a large devil's pentagram was uncovered along one wall during a restoration effort and that it is this demonic symbol that's the cause of the gloomy, ominous sense of foreboding that is said to affect all who enter there. It's said that all of the sinister activities first began when the chapel in the back was blocked off and its twenty-foot-tall stained-glass windows painted over. It's also said that only when the chapel is reopened and rededicated, and sunlight can once again pour freely through the stained glass, will the demonic presence that infects the corridors of the old St. Charles Hospital be forever banished.

Cherry Road

I'm kind of cheating with this story since it's actually in Oswego and not Aurora, but it's too compelling to pass up. Cherry Road is a narrow country lane with no shoulders or stripes, and it winds through cornfields in some of the most desolate farmland imaginable. It's definitely not a place anyone

would want to have engine trouble on a dark and stormy night. Legend has it that a teenage girl died in a terrible car crash on Cherry Road many years ago. She was barely able to scrawl the word "help" on the blacktop in her own blood before gasping out her last dying breath on the road. Now her ghost is said to appear near the bend in the road where she died; sometimes the word "help" mysteriously appears in blood-red letters on the road.

Yes, the road is as bleak and godforsaken as any Stephen King setting, especially in autumn. Yes, it's hard to *not* picture a ghost materializing on the side of the road on a dark, foggy night. And yes, the word "help" really is written on the blacktop in faded red capital letters that look suspiciously like spray paint. But no, there's never been a report of any car-related deaths on Cherry Road. Note that I said "car-related deaths." In July 1994, road workers repairing Cherry Road had made a gruesome discovery. They found a woman's body crammed into a manhole. Bricks had been tied around her ankles, and a wire was twisted around her throat. The autopsy showed that the actual cause of death was poison, and she was dead before her body was stuffed in the drain along Cherry Road. She was later identified as a missing woman from Chicago, but the case was never solved and her killer roams free to this day. Perhaps it is *her* apparition that people have claimed to see roaming the lonely, isolated place where she was so coldbloodedly dumped. Perhaps she is the real story behind the terrifying legend of Cherry Road.

THE GRAMPA-MAN

Here's a heartwarming encounter to finish this book with, told to me by retired cop Mike Dabney. There's nothing in it about Aurora's history—it's just a sweet and very real story to reassure you that ghosts can be angels, too.

Mike pulled up the family van to their house at 605 Jackson Street. He and his son, Scotty, had made a run to the grocery store, and Mike wanted to put the refrigerated things away before going out again to pick up his daughter, Emily, from school. He helped three-year-old Scotty out of his car seat and then grabbed an armful of grocery bags and carried them inside, thinking that Scotty was right behind him. Mike started to unpack the groceries, talking idly to his son, when he suddenly became aware that Scotty wasn't saying anything. Mike closed the freezer door and looked around. Scotty wasn't in the kitchen. He called out, but there was no answer. He walked through the rooms on the first floor, searching and calling. No Scotty. Same with the second floor. He went back outside to the car and looked all around the yard, but there was no sign of him. Mike was getting worried. Scotty loves mischief as much as the next boy and often teases his mom and dad by hiding from them. But as a special needs child he can be unpredictable, and they knew that his behavior often made him a magnet for trouble.

Mike rapped on the neighbor's door, but Scotty hadn't come over to play with their kids. He searched the whole house again, this time taking care to check all of Scotty's favorite hidey-holes—cupboards, closets, under the beds and behind the sofa. No sign of Scotty. Genuinely worried now, Mike

called his co-workers over at the police station. Within minutes, every patrol car in Aurora was on the lookout for Mike's little boy. It was about this time that Mike's wife, Kathy, came home from work to find squad cars in the driveway and her son missing. "She was a little upset that I didn't call her," Mike said later, in what was no doubt the understatement of the year. A neighbor offered to stay at the house with Kathy, while Mike and several other volunteers began to scour the neighborhood.

After a tense hour, the police station received a call from an elderly man who said he and a friend had spotted a toddler walking down the sidewalk near the pharmacy. The friend went to speak with the child to keep him occupied until the police could come. Sure enough, it was Scotty, who had walked a surprising number of blocks away from home. He explained that he was on his way to pick up his sister from school. He lost his way when he made a right at the corner instead of a left but kept on walking, convinced that he'd come upon the school any minute.

Mike and Kathy were terribly relieved and repeatedly thanked the two men for their eagle-eyed assistance. When they got Scotty safely home at last, they scolded him for going out alone.

"I wasn't alone, the Grampa-man was with me," he said.

"Who? The two old men who found you walking down the street by the pharmacy?"

"No, not them! The Grampa-man! He said he was going with me to pick up Emily from school." Mike and Kathy let the matter drop, putting the "Grampa-man" down to their son's imagination, even though he persisted in assuring them he hadn't been walking alone and that Grampa-man had been with him.

Two years later, the Dabney family was visiting Kathy's mother when suddenly Scotty's voice rang out from the living room. "It's the Grampa-man, the Grampa-man! Mommy, who's this man in the picture?" Scotty was excitedly pointing to a photograph on the mantelpiece. Mike and Kathy had forgotten about Scotty's imaginary friend on that day until he said, "Don't you remember the Grampa-man? He walked with me to pick up Emily from school! The man in this picture is the Grampa-man!"

The photo was a portrait of Kathy's father, who had died one year before Scotty had been born. Somehow, the spirit of Kathy's deceased dad had seen Scotty make the wrong turn at the corner and decided to walk alongside to keep his dearly loved, special grandchild out of harm's way.

BIBLIOGRAPHY

PRINT SOURCES

America's Historic Roundhouse Self-Guided Tour. Pamphlet. Aurora, IL: Roundhouse Publishing Company, 2010.

Aurora Census Report and Directory of the City (various issues).

Aurora City and Business Directory (various issues).

Aurora History. Aurora Historical Society newsletter (various issues).

Beacon-News / Suburban Chicago News.

Chicago Sun-Times. "Walter: Do You Believe?" Tuesday, October 31, 2000.

Derry, Vernon. *Thrift Corner Yarns* 99 (October 1970). Aurora, Illinois.

Durant, Pliny. *Commemorative Biographical and Historical Directory of Kane County, Illinois, 1888.* Chicago: Beers, Leggett, & Company, 1888.

Holland's Aurora City Directory (various issues).

Kleen, Michael. *Haunting the Prairie: A Tourist's Guide to the Weird and Wild Places of Illinois.* Rockford, IL: Black Oak Press, 2010.

Ladley, Diane. *Haunted Naperville: Images of America.* Charleston SC: Arcadia, 2009.

Latham, Donna. *Ghosts of the Fox River Valley.* Wever, IA: Quixote Press, 2007.

Le Baron, William, Jr. *The Past and Present of Kane County, Illinois.* Chicago, IL: W. Le Baron Jr. & Co., 1878.

Maurer Cooke, Violet. "The Day the Circus Blew Away." *Old Fox River Magazine* 2, no. 6 (1994).

———. "The Mystery of Devil's Cave; Where are the Devils?" *Old Fox River Magazine* 3, no. 3 (1995).
Naperville Sun/Suburban Chicago News.

Archival Resources

Aurora Historical Society Archives.
Aurora Public Library.
Chicago Tribune Archives. http://pqasb.pqarchiver.com/chicagotribune/advancedsearch.html.
Internet Archive. http://www.archive.org.
Newslibrary Newspaper Archive. http://nl.newsbank.com.

Audio Sources

Morley, Curtis. *Fox Valley Phantoms.* Audio CD 2009. www.foxvalleyphantoms.com.
———. *More Fox Valley Phantoms.* Audio CD 2008. www.foxvalleyphantoms.com.

Internet References

America's Historic Roundhouse. http://www.rh34.com.
Aurora Area Convention and Visitors Bureau. http://www.enjoyaurora.com.
Aurora Beacon News. http://www.suburbanchicagonews.com/beaconnews.
Aurora Cemeteries. http://auroracemeteries.com.
Aurora Chamber of Commerce. http://www.aurorachamber.com.
Aurora Downtown. http://www.auroradowntown.org.
Aurora Township. http:// www.auroratownship.org.
City-Data.com. "Aurora: History." http://www.city-data.com/us-cities/The-Midwest/Aurora-History.html.
City of Aurora. http://www.aurora-il.org.
Encyclopedia of Chicago. "Aurora, IL." http://www.encyclopedia.chicagohistory.org.
Ghost Research Society. http://www.ghostresearch.org.

Ghostly Talk—Paranormal Talk Radio. http://www.ghostlytalk.com.

Ghostvillage. http://www.ghostvillage.com.

Graveyards.com. "Graveyards of Illinois—Chicago." http://www. graveyards.com.

Haunted Destinations. "Illinois." http://www.ghosttraveller.com/Illinois. htm.

Haunted Places Directory. http://www.haunted-places.com.

I Am Haunted. http://www.iamhaunted.com.

Illinois Trails. "Kane County—Aurora Cemeteries." http://www.iltrails. org/kane/auroracem.html.

Kane County. "Aurora Township, Aurora, Eola, North Aurora & Montgomery." An www.ancestry.com community. http://freepages. genealogy.rootsweb.ancestry.com/~ilkane/AuroraFrame1Aurora1.htm.

Paramount Theatre. http://www.paramountarts.com.

Shadowlands Ghosts & Hauntings. http://theshadowlands.net.

Wikipedia, the Free Encyclopedia. http://en.wikipedia.org.

Will County Ghost Hunters Society. http://www.aghostpage.com.

ABOUT THE AUTHOR

Diane Ladley is the founder and president of Historic Ghost Tours of Aurora, Historic Roundhouse Ghost Tours, Historic Ghost Tours of Naperville and the Haunted Hometowns Corporation. Her first book, *Haunted Naperville* (Arcadia Publishing, 2009), was widely acclaimed and praised by critics for its highly readable style and in-depth scholarship. Ladley is a nationally award-winning storyteller, local folklorist, public speaker and writer, renowned as "America's Ghost Storyteller." Her coast-to-coast reputation for masterfully told, spine-tingling tales is hailed by critics, peers and ghost story enthusiasts alike. She was a State of Illinois ArtsTour Artist for 2001–3 and again in 2003–5. In 2003, Ladley's own adaptation of a classic folktale, "The Liver," from her *Late Night Fright: Tales of Supernatural Terror and Macabre Mirth* audio CD won a national Storytelling World Honor Award for "Best Story of the Year for Adolescents." Ladley is the foremost authority on local supernatural lore, and after two years of dedicated research and personal interviews, she is proud to be the first to offer the authentic, comprehensive haunted history of Aurora.

Author's collection. Photograph by Dan Muir, A Shot in the Dark Photography.

Visit us at
www.historypress.net